Chinese Arts & Crafts

Chinese arts and crafts enjoy a unique reputation in the history of material culture and civilization. For several thousand years, crafts have echoed the rhythm of daily life in China. From rural society to the imperial court, these crafts have served a practical purpose, constantly evolving with changes in lifestyle. In this illustrated introduction Hang Jian and Guo Qiuhui discuss the colorful history and development of distinctive Chinese crafts, including ceramics, furniture, clothing and decorative arts.

Introductions to Chinese Culture

The thirty volumes in the Introductions to Chinese Culture series provide accessible overviews of particular aspects of Chinese culture written by a noted expert in the field concerned. The topics covered range from architecture to archaeology, from mythology and music to martial arts. Each volume is lavishly illustrated in full color and will appeal to students requiring an introductory survey of the subject, as well as to more general readers.

Hang Jian

Guo Qiuhui

CHINESE ARTS & CRAFTS

CAMBRIDGE
UNIVERSITY PRESS

CAMBRIDGE UNIVERSITY PRESS
Cambridge, New York, Melbourne, Madrid, Cape Town,
Singapore, São Paulo, Delhi, Tokyo, Mexico City

Cambridge University Press
The Edinburgh Building, Cambridge CB2 8RU, UK

Published in the United States of America by Cambridge University Press, New York

www.cambridge.org
Information on this title: www.cambridge.org/9780521186551

Originally published by China Intercontinental Press as *Chinese Arts and Crafts*
(9787508516080) in 2010

© China Intercontinental Press 2010

This updated edition is published by Cambridge University Press with
the permission of China Intercontinental Press under the China Book
International programme.

For more information on the China Book International programme, please visit
http://www.cbi.gov.cn/wisework/content/10005.html

Cambridge University Press retains copyright in its own contributions
to this updated edition

© Cambridge University Press 2012

First published 2012

Printed and bound in China by C&C Offset Printing Co., Ltd

A catalogue record for this publication is available from the British Library

ISBN 978-0-521-18655-1 Paperback

NOT FOR SALE IN THE PEOPLE'S REPUBLIC OF CHINA (EXCLUDING HONG
KONG SAR, MACAU SAR AND TAIWAN)

<u>**Contents**</u>

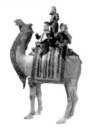

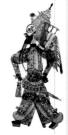

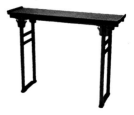

Preface

The traditional arts and crafts of China are unique in the history of material culture, because of the unique geographic location of China and its long tradition of agricultural food production. Since the Han Dynasty and the gradual formation of the Silk Road, the traditional arts and crafts of China were introduced to the Middle East first via Central and Western Asia and then to Europe and beyond. In traditional Chinese philosophy, ancient thinkers started, as early as the first century, to use handicraft skills as metaphors for ways of running a state or looking at life.

The coastline of China is long, but the origin of its civilization, the Central Plains region (comprising the middle and lower reaches of the Yellow River), lies deep inland. The three earliest systems of state power in China, the Xia Dynasty, the Shang

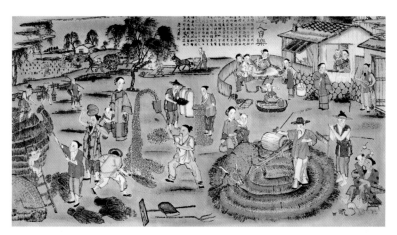

Happy Farmers, a New Year picture from Yangliuqing, depicting a traditional rural scene.

Dynasty and the Western Zhou Dynasty, all emerged in this landlocked region. For the cultures that emerged on plains as well as in mountain areas, agriculture aided by irrigation was the main means of subsistence. This led to the development of the astronomical calendar, farming tools, and a social system based on the rhythms and culture of traditional farming life. It was this kind of life and the particular style of art in traditional farming society that defined what would become the special features of the traditional arts and crafts of China. The skills and tools that developed were a reflection of the traditional practice of tilling the farm by men and spinning and weaving by

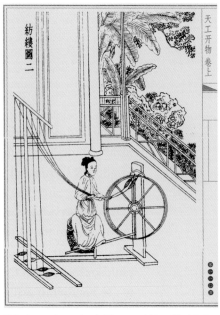

Spinning and weaving in *Tiangong Kaiwu* (Exploitation of the Works of Nature).

women, and the way people's working lives were lived from sunrise to sunset. The original form of all articles and utensils was closely related to their purpose. Every tool should be convenient and simple to use, as appropriate for an agricultural civilization. Even at their most accomplished level, in arts and crafts for court use and for the elite, the idea of practical use and the tradition of simplicity were still maintained. The main decorative style was inspired by nature. Hills, lakes and rivers, animals and plants were the main patterns and ornaments. Outlandish or garish decorations were scarcely seen. The traditional Chinese saying "Finding amusement in things of mere pleasure ruins aspirations" reflects a suspicion of excessive development of skills that had no practical value. The influence of this idea has made functionalism the driving force of Chinese arts and crafts for thousands of years. Nevertheless, it has also brought

about a certain conservatism, as social and scientific progress was held back.

The philosophy of the traditional arts and crafts of China can be summed up by the following six ideas:

The first aspect is "respect oneself and be the master of things." This human-oriented view of material production seems self-evident, yet reflects a difference between China and Europe. After the Industrial Revolution in Britain, mechanized production lowered the costs of production and created the cheapest products, which was widely welcomed as an economic benefit. However, dissatisfaction with machine-made products set in, as they were too uniform and often poorly made, and there remained a preference for handmade items which reflected the maker's individuality. Additionally, assembly work made workers into part of the machine and denied any pleasure in the work itself. Traditional manual labor, it was believed, could give people a feeling of closeness to the natural materials, of the pleasure of physical touch and of knowing the materials with which they were working. When working in harmony with the rhythm of the agricultural economy, it was thought that the people had a kind of natural pleasure in their rural pursuits. Mechanical production in China was highly developed at an early stage, particularly at what is now recognized as the rudimental stage of capitalism at the end of the Ming Dynasty. At Songjiang (in the modern-day Jiangsu Province), the cotton-weaving industry was particularly well organised. Quite a few households had five to ten hand looms and even employed workers to operate them, with a clear division of labor between production processes. Nevertheless, this kind of production did not develop into a commercial large-scale industry such as we know today. These seeds of capitalism at the end of the Ming Dynasty did not lead to a great increase in the volume of production, nor cause revolutionary changes in the textile

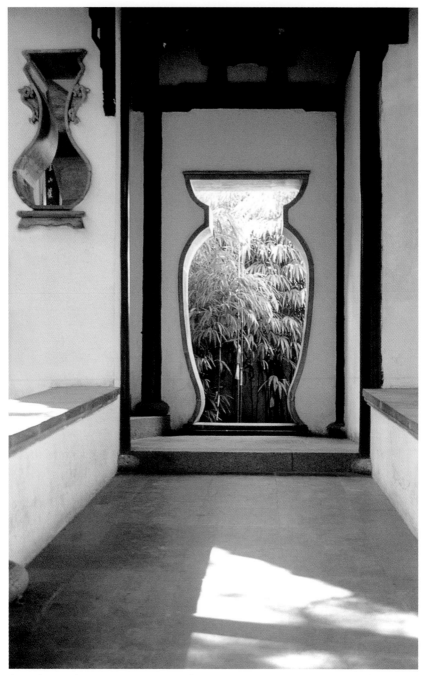

An unadorned, elegant garden to the south of the Yangtze River.

industry like those seen in the Industrial Revolution in Britain. Those cotton-weaving proprietors of the Ming Dynasty, still closely aligned with agriculture, invested their profits back into agricultural production or into the development of their private families, by housebuilding, land purchase, marriages and raising children. While this led to the agricultural economy stagnating, it also reflects how the feudal society of China preferred to enhance and benefit people's lives, rather than develop mechanical production for its own sake.

The second idea is "to attain practical use and to benefit man," emphasising that crafts' main purpose was utility and people's livelihood. During the Qianlong Reign (1736–1795) of the Qing Dynasty, when Western missionaries or diplomatic envoys of various countries came to China, most of the gifts they presented to the emperor were playthings, such as automated clocks. These were examples of Western inventions not solely made for practical use or for economic benefit. In contrast, objects manufactured in ancient China always laid stress on functional uses. Guan Zhong (c. 725–645 BC), a thinker of the Spring and Autumn Period, praised wise craftsmen in ancient times who always followed the rule of not wasting their wisdom to make playthings that were of no use to people. Mozi (c. 468–376 BC), a thinker in the Warring States Period, also believed in "doing

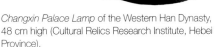

Changxin Palace Lamp of the Western Han Dynasty, 48 cm high (Cultural Relics Research Institute, Hebei Province).

what is beneficial to people and not doing what is not beneficial to people." Today their views may seem over-simplified, but at the time they were of great significance and throughout Chinese history handicrafts were limited to producing such items as were necessary for practical purposes and beneficial to the work of the people.

The third traditional Chinese idea about arts and crafts is "to give full play to the actual shape of raw materials by careful examination." It stresses the relationship between arts and crafts on the one hand and skills and materials on the other. For instance, when making furniture, skilful carpenters knew how to make use of the characteristics and grain direction of timber to create the shapes they wanted; when making ink stones, good artisans knew how to make use of the innate quality of a particular piece of stone to shape it perfectly; and when carving jade, the best artisans knew how to give full play to the "coincidental natural colors" on a piece of jade. These are only small examples of how handicraft articles were made in accordance with the unique qualities of the natural materials used. The traditional arts and crafts of China paid great attention to materials and technical conditions and designed articles in line with functional requirements. When talking about how to design a landscape in his *Xian Qing Ou Ji* (*Casual Expressions of Idle Feeling*), Li Yu (1610–1680, a famous man of letters at the turn of the Ming and Qing Dynasties) said the essential thing in landscaping was overall harmony. Living in a mostly agricultural society, the Chinese never made any object that was external to that society and all handicraft articles reflected this way of life. The gilded bronze lamp of the Changxin Palace from the Western Han Dynasty is one of the outstanding examples of Chinese traditional handicrafts. Its ingenious design filters smoke by making use of sealed water, discharges the smoke with a flue and adjusts the light with a rotating structure.

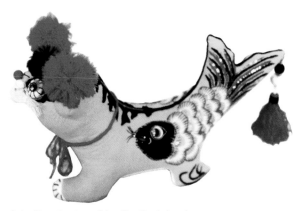

Folk pillow showing a fish with a tiger's head.

The fourth idea is "to follow nature with ingenuity." Inspiration should be drawn from the natural world so as to maintain harmony between man and nature. The term "to follow nature" has often been considered to apply most to painting. In fact, it has also had an immense influence on the traditional arts and crafts of China. In ancient China, its expression was particularly evident in items such as the various lamps and lanterns of the Han Dynasty, the saw invented by master artisan Lu Ban (c. 507–c. 444 BC) and the competition of flying kites between Lu Ban and Mozi. The inspiration for all this was drawn from nature. In addition, the wooden ox and gliding horse invented by Zhuge Liang (181–234), mentioned in the *Romance of the Three Kingdoms,* for transporting army provisions along the narrow valleys of Sichuan Province were also designed by combining machinery and shapes taken from nature. There were many similar examples in ancient times. Even some instruments for astronomical observation, such as the seismograph invented by Zhang Heng (78–139), a Chinese scientist of the Eastern Han Dynasty, were made by imitating or referring to shapes from nature. *Xiu Shi Lu* (*Lacquer in Ancient China*), a monograph about lacquer handicraft written in the Ming Dynasty, put forward explicitly the idea of "following nature in an ingenious way."

During the Qianlong Reign many luxury goods were made of porcelain in animal shapes. Folk utensils were also made in animal shapes, such as fish-shaped plates, incense bags, cake molds, gate locks and so on. The shapes of animals not only have functional significance but are also unique symbols of Chinese folk culture.

The fifth idea is "to convey truth with skills": skills were considered to contain ideological elements and attention should be paid to both ideas and things so that day-to-day functionality and technical labor are aligned with higher ideals, doctrines and theories. As early as the pre-Qin Dynasty, this concept was formed largely under the influence of Taoism. Confucianism held the similar view, "to convey truth in writings." Though the relationship between theory and practice was often unresolved in Chinese intellectual history' and the tendency to look down on practice and favor theory was widespread, theory has never been more important than practice in the daily life of ordinary people.

The sixth idea, from Confucianism, is "to balance outward grace and solid worth," that is, the unification of content and form in nature should drive the unification of function and decoration in handicraft articles. This interplay between function and decoration has stopped Chinese art from being solely functional or formalist. Balancing outward grace and solid worth extends beyond objects to a way of life, code of conduct and the relationship between man-made articles and man.

These six key ideas are what might be termed the "wisdom" of the traditional Chinese arts and crafts, as written by imperial nobles or scholars. However, folk wisdom related to the purpose and development of handicrafts is richer, full of an independent symbolism expressed in objects as well as pithy sayings (often in rhyme), legends and stories. Though some over-elaborate, excessive tastes arose during some periods in history, the traditional arts and crafts of China, expressed temperance and restraint in combination with real aesthetic quality and style.

The Traditional Arts and Crafts of China

Prehistoric China

In the first stages of human society, stone tools were the main implements of production. Through the creation of stone artifacts, man gained a better understanding of what he could achieve in manually working materials and thus the various different handicrafts gradually developed. As early as 1,700,000 years ago, in the era of "Yuanmou Man" in Yunnan Province, China, the people of China began to make rough stone implements and weapons. At the time of the Upper Cave Man, 17,000 years ago, many kinds of stone artifacts and a number of

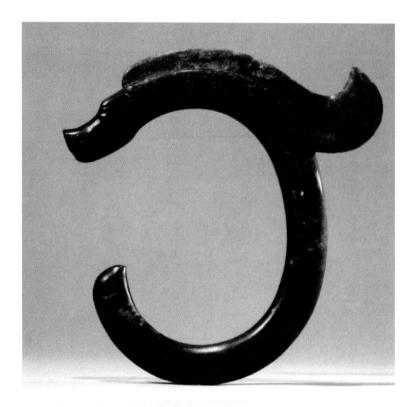

Jade dragon of the Hongshan Culture (Wengniute Prefecture Museum, Inner Mongolia Autonomous Region).

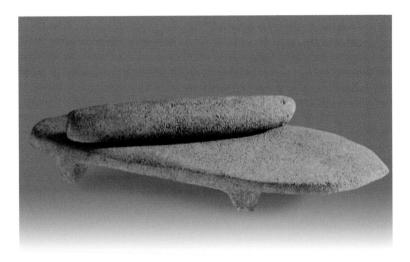

Stone club and millstone from the Neolithic Age.

technologies and skills had developed, such as drilling, scraping and polishing, and line engraving was already being used. While these kinds of fabrication were primarily functional tools, rudimentary decoration also appeared, reflecting the developing aesthetic consciousness of prehistoric man. The Upper Cave Man also learned how to drill wood to make fire, making a great leap in man's ability to survive. The use of fire made possible all the later crafts, for example the invention of pottery and metallurgy, which were of extraordinary significance in the development of human culture.

In selecting raw materials for stoneware, people began to choose precious stones with close grains and sparkling colors. With meticulous processing, they made the stones into ornaments, either for carrying with them or being buried with them after death. Jade ware was the main craft to develop from this.

Prehistoric buildings reflect man's growing need for settlement. In line with their respective geographic conditions, people of the clan society in ancient China built dwelling places

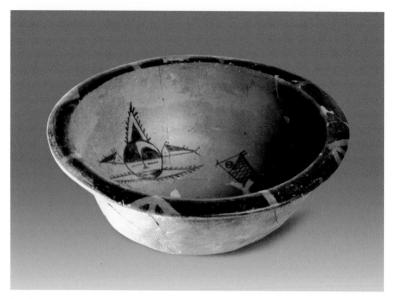

Pot decorated with a face from the Yangshao Culture of the Neolithic Age (National Museum of China).

in different styles, including the semi-underground houses of the northern Yellow River Valley and nests in trees in the southern Yangtze River Valley. To build their houses, people developed carpentry skills. From the remains of dwellings excavated in Yuyao, Zhejiang Province, we can see that people there already lived a settled life in houses built with earth and wood seven-thousand years ago.

At first, when processing natural materials, people were only able to change their appearance with basic tools, but using fire for clay pottery-making represented a qualitative leap forward. Earthenware not only enriched utensils for daily life but also increased the stability of the settled farming life. As a patriarchal society emerged, pottery-making developed from a community undertaking by a clan to a specialized craft controlled by a family. Technology was improved and pottery varieties were

increased, to include grey, black and white pottery made with china clay.

The handicraft culture of ancient China reflects the respective advantages of different geographical regions in their specialization. For instance, Yangshao Culture in the north (7,000–5,000 years ago) excelled at painted pottery, the sculptures of the Hemudu Culture in the south (c. 7,000 years ago) were remarkable, and the Longshan Culture in the east (5,000–4,000 years ago) excelled at modeling. Already in these prehistoric times the unification of practical use and decoration was a central feature of Chinese workmanship.

The Xia, Shang and Zhou Dynasties (2070BC – 771BC)

Starting from the Xia, the Shang and the Western Zhou, China began its long history of rule by successive dynasties. Both the Xia and the Shang had official government posts specially set up to manage handicrafts under the direct control of royal families and nobles. The sacrificial vessels, sacrificial utensils, weapons and valuable articles for daily use needed by the rulers were all created by craftsmen working under the control of officials. Most of the craftsmen of the Shang Dynasty belonged to clans who were traditionally specialised in a particular craft from generation to generation, but some were slaves and former prisoners of war.

Bronze ware was an important craft in the Shang Dynasty (1600 – 1046 BC). The typical decoration consisted of symmetrical or single line patterns, both mysterious and solemn. Drinking vessels were the most common bronze objects, expensive and used exclusively by the elite. The masses still used earthenware for their daily necessities. As a result, the pottery-making

technique of the Shang Dynasty was also highly developed. There were three kinds of techniques to make pottery: by wheel, by mold and by combining the two. There was also an internal division of labor between these pottery-making techniques, and different kilns fired different classes of pottery. China was the first nation in the world to breed silkworms (domesticated since the Shang Dynasty) and weave silk fabrics. Lacquer, too, was first developed in China at this time. A coating of lacquer can prevent wooden articles from rotting and be used for decoration as well. Under the Shang Dynasty, religious significance governed the making and use of crafts much more than any aesthetic considerations.

The Western Zhou Dynasty (1046 – 771 BC) is characterised by three different political systems: the system of granting titles and territories to the nobles; the hereditary system; and the hierarchical distribution of power. Ritual was highly important, which affected the formation and development of manufacturing dress and personal adornment, utensils, palace chambers and horse-drawn carriages. In the economy, the "nine squares" system of land ownership (one large square divided into nine small ones, the eight outer ones being allocated to slaves who had to cultivate the central one for the owner) was adopted, which expanded the scale of agricultural

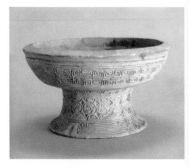

White pottery *dou* (hollow container) from the Shang Dynasty, decorated with elegant patterns of storm clouds.

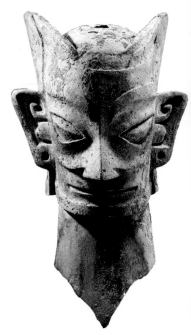

Bronze mask from the Shang Dynasty, discovered in Sanxingdui in Guanghan City, Sichuan Province, in 1986.

production. Collective labor meant farming techniques were more easily shared. The large number of artisan slaves captured by the Zhou Dynasty in the process of conquering the Shang Dynasty also stimulated the development of handicrafts.

According to the *Kao Gong Ji* (*The Records of Examination of Craftsmen*), the earliest book on handicrafts in China, the Western Zhou Dynasty divided society into six categories: the nobility, the literati and public officials, craftsmen, traveling merchants, farmers and needle workers. At that time the division of labor and skills was elaborate: there were thirty kinds of work within six main trades: carpenter, bronzer, tanner, painter, carver and pottery maker. Manufacturing was controlled by local authorities who provided specialist craftsmen with raw materials and workshops. The authorities also coordinated several trades working together, for example when the cooperation

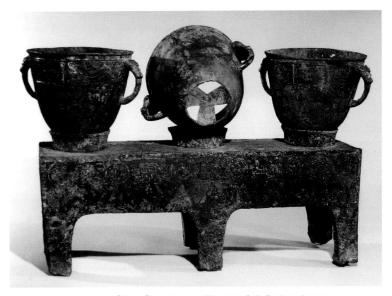

Three-in-one *yan* from the Shang Dynasty, a cooking utensil similar to a steamer.

of carpenters, bronzers, lacquerers and tanners was needed to manufacture a chariot. The handicrafts of the Western Zhou Dynasty, such as bronze ware, dyeing and weaving, lacquer ware and jade ware, reflected the ritualised social structure, with differences in quantity, shape, color, lines and grain as well as use between objects made for different social strata. For the basic utensils of survival, farm tools and weapons, bronze ware remained in use, often engraved with long inscriptions recording sacrifices to gods or ancestors, eulogizing a hero's virtues, granting a reward, effecting exchanges, contracting marriages or bringing a court case. Decoration tended to be plain and simple. The fabrication and use of primitive porcelain were also rather popular, with the technique of applying glaze greatly and visibly improved, and the solidity, moisture absorption and mineral composition now closer to that of later porcelain.

The Spring and Autumn Period and the Warring States Period (770BC – 221BC)

During the Spring and Autumn Period and the Warring States Period, with the integration of the slave system and the gradual establishment and development of the feudal system, handicraftsmen were taken out of slavery. This raised their social status, and with this motivation their skill and productivity increased. This period produced many items made with exquisite workmanship, beautiful shapes and unique creativity, particularly in metallurgy, ceramics, dyeing and weaving and lacquer ware.

During the Warring States Period, the iron-smelting industry came into being from copper metallurgy and China fully entered the Iron Age. There were many pottery-making workshops run by the government or by self-employed artisans, all focusing mostly on gray pottery. Due to the tradition of elaborate funerals,

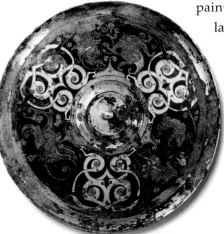

Mirror from the Warring States Period with hunting scenes inlaid in gold and silver.

painted pottery was rapidly developed. As lacquer ware was anticorrosive, moisture-proof, light in weight and attractive, it began to develop at this time, most significantly in the Kingdom of Chu. Due to the development of iron smelting, the improvement of pottery-making and the appearance of lacquer ware, bronze ware declined and was gradually replaced by lacquer ware. Dyeing and weaving technology and production were widely distributed, but the most advanced was found in Qi (the present northern Shangdong) and Lu (the present southern Shangdong).

Both "knee-deep" clothes (one-piece suits) and *hufu* (separate jackets, trousers and boots worn by non-Han nationalities living in the north and west in ancient times) were worn. Gradually the *hufu* fashion from the northern grasslands was introduced to the Central Plains, and found to be more convenient both for daily life and for warfare.

The Spring and Autumn Period and Warring States Period saw an intellectual and academic flourishing in Chinese culture, with the emergence of the main schools of thought, Confucianist, Taoist, Mohist and Legalist, which had an impact on the arts and crafts of the period. For instance, the Confucian School laid emphasis on the unity of content and form; the Taoist School advocated that "great art conceals itself"; the Mohist School emphasized "economization" and "content first, form second"; finally, the Legalists were against forms but for functions. The divergent schools of thought and their exponents all regarded technology and manufacturing as an important advancement. They often evoked technical skills to expound their theories,

and make use of objects to give explicit instructions and practical examples. This dynamic intellectual culture made the workmanship of this period notably clever, creative and innovative.

At that time, in many states the handicraft industry was run by dukes and princes or by self-employed artisans. Each state developed its specialist set of skills and talents and became famous

Yellow silk quilt with line embroidery of phoenixes and dragons in pairs from the Warring States Period (detail).

Kao Gong Ji (The Records of Examination of Craftsmen).

for its excellence in a particular product: the lacquer ware and leather-making of the Chu State, the swords of the Wu and Yue States, the bows and cross bows of the Han State, the iron-smelting of the Zhao State, the bamboo ware and woodenware of Ba and Shu States, the pottery-making of the Qi State and the jewelry of the southern coastal area. The shape of utensils made in the Chu State was tall and straight and the decoration was in a romantic style, full of fantasy; the articles made in the Qin State were of a plainer, more realist style; the Zhao State was known for its simplicity and vigorousness; the Zheng State, for its exquisiteness and ingeniousness; the Yan State, for its primitiveness and simplicity; and the Han State, for its refinement and elegance. The handicraft articles made in the various states all reflected the strong flavor of their respective styles.

The Qin and Han Dynasties (221BC – 220AD)

Goujian's bronze sword from the late Spring and Autumn Period, still very sharp today, a masterpiece of the Wu and Yue states.

The period of the Qin and Han Dynasties saw the establishment and consolidization of a centralized feudal monarchy uniting multiple nationalities within the Chinese state. The centralization of state power required that

manufacturing be brought under a single command and directed on a grand scale. Examples of these great projects are the world-famous architecture and statues of the Qin Dynasty, such as the Great Wall and the tomb of the First Emperor of the Qin Dynasty with its terracotta warriors and horses.

There were two kinds of operation for the arts and crafts: government workshops and self-employed artisans. The former mainly met the demands of the Imperial household and the nobility, the *yamen* (government officers in feudal China) at all levels and the army. So its scale was large, the trades were numerous, the division of labor was elaborate, the management was tightly controlled, and funds were abundant. As for the

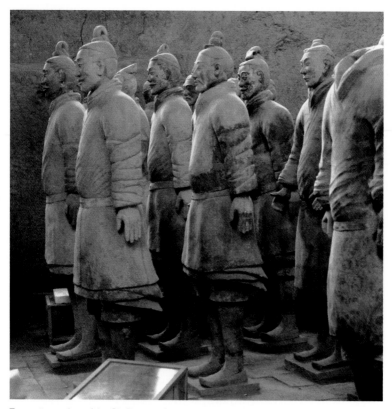

Terracotta warriors of the Qin Dynasty, found in the tomb of the First Emperor of the Qin Dynasty in Lintong, Shaanxi.

smaller, independent craftsmen, they were still supported within the traditional economy of the self-supporting and self-sufficient agricultural society.

The government-run industries of the Qin Dynasty included mining, smelting and casting, arms and weapons, manufacturing carriages and chariots, tools and implements, lacquer ware and earthenware. The government, both at central and local levels, set up large-scale handicraft administrations. During the Qin and Han period, the iron-smelting industry developed rapidly. With the emergence of well-tempered steel forged several times, the quality of ironware like weapons and farm tools was greatly improved. At the beginning of the Qin Dynasty, arts and crafts were directed to practical use with simple and unadorned shapes. As the rule of the Qin Dynasty lasted for only fifteen years, not many handicraft articles have survived and what is left is mainly bronze ware, lacquer work and earthenware.

During the Han Dynasty, arts and crafts developed further, retaining the tradition of unity of practical purpose and aesthetic awareness, and inventing single objects with multiple uses. For instance, a copper lamp that is not only convenient for use but also highly decorative, or a lacquer case cleverly designed to maximize its internal space. Spinning and weaving was an important industry at this time and thousands of people worked

Roof tiles of gray pottery from the Han Dynasty, each showing a god.

in the government-run workshops. The textiles of the Western Han discovered at Mawangdui in Changsha, Hu'nan Province, are varied and display exquisite workmanship, representing the high standard of textile technology of the time. The cities of Linzi in Shandong, Chenliu in He'nan and Xiangyi in Hubei were the main centers of Han textile production.

The arts and crafts of the Han Dynasty often took their inspiration from daily life, using scenes of feasting, dancing, hunting, plowing and sowing, harvesting and smelting. As Confucianism was developing into a religion, religious themes became more important in ornamentation, inspired by the rise of divination combined with mystical Confucianist belief as well as the practice of elaborate funeral rites, to represent the ascension to heaven and immortality, auspicious signs and superstitions, and the gods of the four directions. The main ornamental technique used was silhouette, which was able to express dynamic characteristics. The composition was rich but regimented, with multiple decorative elements arranged according to a pattern. During this period, there was much trade and exchange between different regions and nationalities, forming a unified domestic market. As a result, many craftsmen also became merchants and the tradition of selling and marketing one's own products began to gain popularity.

Four Deities: Blue Dragon, White Tiger, Crimson Bird, Black Tortoise

Originally the four deities were powerful and intelligent animal divinities worshipped in ancient China. Their worship is closely associated with a reverence for constellations. Looking up at the boundless sky, people in ancient times divided the stars into groups, giving each the name of a human being, animal or deity, as was practiced in China as well as overseas. Each season was associated with a different part of the night sky. The constellations seen in the south at dusk in spring were thought to be shaped like a bird, and called Crimson Bird, whereas the stars in the north seemed to resemble a dragon, hence Blue Dragon, those in the west were called White Tiger and those in the north Black Tortoise.

And thus Blue Dragon, White Tiger, Crimson Bird and Black Tortoise came to be the four deities guarding the Heavenly Palace, fighting evil and harmonizing Yin and Yang in Chinese mythology. As the theory of Yin and Yang and Five Elements grew in importance, the four deities as guardian spirits played a more central role. The gates, watchtowers, halls and towers of ancient palaces were often named after the four creatures and they were widely used in decoration and as ornaments.

Black lacquer plate from the Western Han Dynasty, decorated with cloud patterns in scarlet and grayish green lacquer. The three auspicious Chinese characters in the middle written in scarlet lacquer are combined with decorative patterns, a style very popular in the Western Han that has become typical of Chinese decorative arts.

Bi Xie (a holy beast believed to be able to get rid of evil spirits), carved from bluish white jade from the Western Han, (Xianyang Municipal Museum, Shaanxi).

Zhang Qian of the Han Dynasty, twice an envoy abroad to the Western Regions, opened the Silk Road by land from Chang'an directly to Central Asia, Western Asia and the eastern coast of the Mediterranean. In addition, a land pass to India was opened and the route along the coast of China to Japan via Korea also became an important trade corridor. The economic and cultural exchanges between China and other countries increased as China began to export silk fabrics, lacquer ware, ironware and handicraft articles throughout the world.

The Six Dynasties (220-580)

During the period of the Six Dynasties, wars occurred frequently in the north but the south was comparatively stable. The subsequent migration of a large number of people and skills to the south enhanced its economy. Where the north had previously been the center of the economy and of manufacturing, China became more balanced in this respect.

The Six Dynasties, following on from the Western and Eastern Han Dynasties and handing over to the Sui and Tang Dynasties, was an important transitional period in the history of arts and crafts production in China. Social turbulence and the sufferings brought about by war stimulated the rise and dissemination of Buddhism and the concepts of karma and samsara. Rulers also used

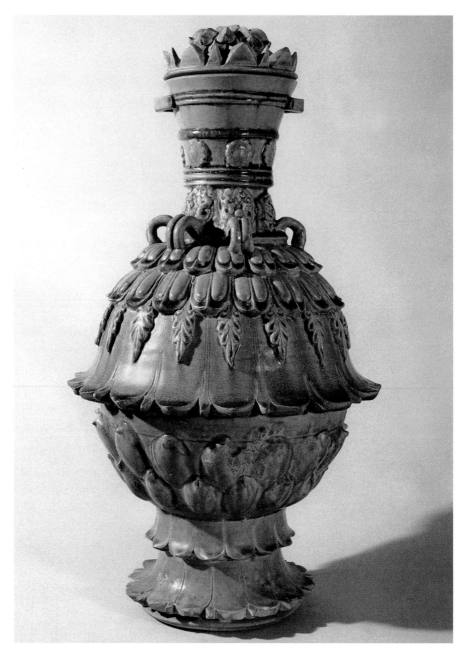

Celadon *zun* (a kind of wine vessel) from the Northern Dynasty beautifully patterned in the shape of a lotus, a representative work of northern celadon.

Art of Gandhara
In the northwest of the South-Asian subcontinent (now north Pakistan and northeastern Afghanistan), Buddhist art flourished between the first and fifth centuries. The Gandhara region was originally one of the sixteen ancient states of the Subcontinent. Its political centre was in the region of modern-day Peshawar, Pakistan. In the reign of the Mauryan dynasty Buddhism was introduced to Gandhara, which soon became the central region of the Kushan Empire with its flourishing arts and culture. The art of Gandhara refers primarily to Buddhist art during the Kushan Empire. As the empire was located in a hub of communication between India and Central and Western Asia, and had been under the rule of Greece (during the expedition of Alexander the Great) and Tukhara over a long period of time, its art combines influences from India and Greece, and is sometimes called "Greek-style Buddhist art."

Buddhism to consolidate their rule and encouraged the spread of Buddhism energetically. In the north, many grottos were dug. The well-known Mogao Grottoes in Dunhuang, the Datong Grottoes, and the Luoyang Grottoes are all pioneering works dating from this period. In the south, Buddhist temples were widely built and Buddhism inspired all kinds of arts and crafts: brass and copper ware, gold vessels, silverware, carved stone, textiles embroidery and lacquer ware all reflected Buddhist thought. Lotus and honeysuckle, the main ornaments of the time, became the symbols of Buddhism. The prevalence of Buddhism also contributed to the expansion of international exchanges. Monks from India and craftsmen from Central Asia introduced Greek and Persian styles, via Indian art, to China and changed the direction of Chinese material culture. Therefore, the religious trend and the foreign influence on industrial art are the key features of the arts and crafts of the Six Dynasties.

In the ideological sphere, metaphysics prevailed. Supported by the ideology of Laozi (Li Er), Zhuangzi (Zhuang Zhou) and *The Book of Changes*, metaphysics paid close attention to the reality of personal existence, expounded the special relationship between man and society and between man and nature, and encouraged a meditative detachment from reality. This was reflected in the industrial arts as a theme of keeping aloof from worldly things. For example, these subjects were exemplified in the images of the "Seven Sages of the Bamboo Grove," made with tiles displaying

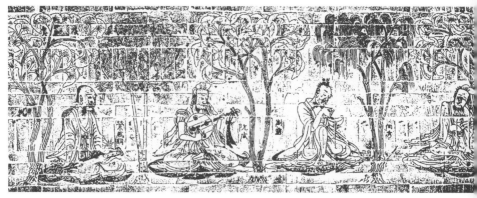

Seven Sages of the Bamboo Grove, a mosaic showing scholars gathered in a bamboo grove drinking and composing poems in the period of Wei and Jin.

both delicacy and simplicity. Brick pictures were particularly used to represent sages and men of virtue. Compared with the Han Dynasty, the industrial art of the Six Dynasties was richer and more joyous, and was also penetrated with the elements of Buddhism such as the lotus, curly grass, rocks and trees. Benefiting from the

Glass bowl from the Northern Wei.

improvement of technological skills, the Six Dynasties produced large-scale themed murals, made of a number of pictures joined with tiles.

By the Six Dynasties, China had entered the porcelain age. Though primitive porcelain was made as early as the Shang Dynasty, it was not until the later Han Dynasty that it was perfected. Not only is porcelain solid, easy to wash, heat-resistant and acid- and alkali-resistant, but also fine, smooth, warm and moist to the touch, and translucent. Since then, ceramic has become a main material of people's household necessities that even now cannot be completely replaced by modern products made of glass, plastics or aluminum.

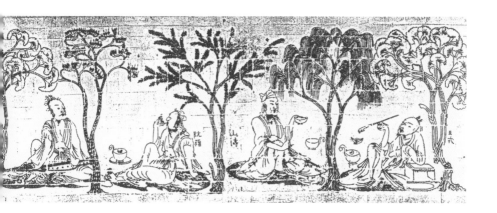

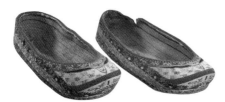

Shoes from the Eastern Jin: the sole woven with flaxen thread and the other parts with silk thread of brown, red, white, black, blue, yellow and green (Xinjiang, Uygur Autonomous Region Museum).

The patterned satin woven in Sichuan was the most famous textile product of the Three Kingdoms and the Western and Eastern Jin Dynasties. However, in the Southern Dynasty, dyeing and weaving technology was also universally developed in the regions south of the Yangtze River. Jingzhou and Yangzhou were the major local centers of silk weaving. During the Six Dynasties, silk weaving became more regular, most commonly employing geometric patterns. By this time, handicraftsmen had already obtained a certain degree of independence and freedom, both in their work and in the techniques they developed and used. This period saw a lot of innovation: for instance, during the period of the Three Kingdoms, the politician and strategist Zhuge Liang invented the wooden ox and gliding horse, a means of transport in mountainous regions; Ma Jun, a master artisan, invented a farm tool for conserving water, later named the "keel-plate waterwheel," and productivity was greatly improved.

The Sui, Tang and Five Dynasties (581-960)

The Sui and Tang Dynasties were a time of great prosperity in ancient China. As the reunified nation state was further developed and consolidated, both the economy and culture prospered.

The government still controlled the main handicraft departments and the administrative systems were further organized in respect of scale, organization, division of labor and technology. Many products were sold abroad through tributes, grants and trading and at home through a monopoly on goods. The specialization of labor became even more elaborate. Artisans of different professions had to receive technical training and study from nine months to four years. For instance, metal smiths for four years; musical-instrument makers and chariot makers, three years; and bamboo artisans, carpenters and lacquerers, one year.

The emergence of guilds further advanced folk handicrafts producing daily commodities. In addition to farmers' household handicrafts and the handicrafts run centrally by a bureaucratic landlord from his manor, folk handicrafts gradually drew towards the city. Handicraft workshops developed rapidly, for example in dyeing and weaving, porcelain, lacquer ware and woodwork, gold and silverware, jade ware, smelting and casting, vehicle and boatbuilding, papermaking and printing, and grain processing. In the Tang Dynasty, commercial organizations similar to guilds also emerged to coordinate internal relations within the trades and stipulate regulations for production and sale; these were recognized and protected by the government. Guild organization greatly affected the social economy, universally improved the social status of the handicraftsmen and marked a new stage of development for the handicraft industries of China.

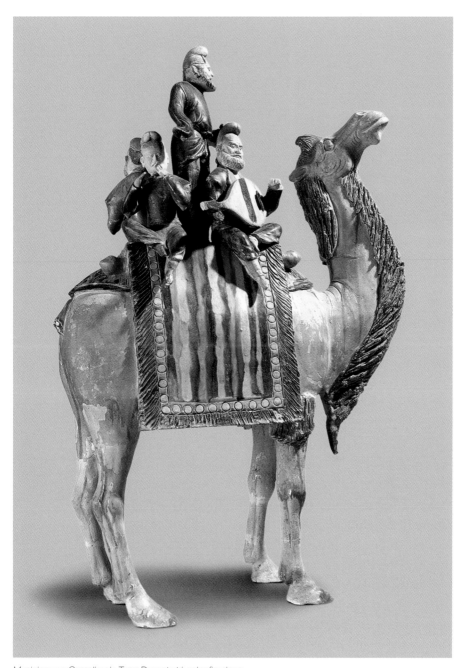

Musicians on Camelback: Tang Dynasty tri-color figurines.

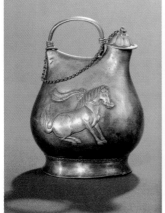 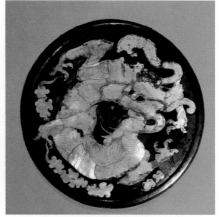

Silver pot from the Tang Dynasty showing a dancing horse holding a cup in its mouth (Shaanxi Museum).

Bronze mirror from the Tang Dynasty with brown lacquer coated on the back, inlaid with a mother-of-pearl dragon coiling in clouds.

In the Sui Dynasty, ceramics, dyeing and weaving, and ship-building were the most important trades. In the Tang Dynasty, due to the highly developed economy, liberal state policies, and frequent exchanges between China and foreign countries, brocade, textile printing and dyeing, ceramics, gold vessel and silverware, lacquer ware and woodenware all advanced in this period. The ornamental style of this period was different from the simplicity and unadorned style characteristic of the Shang, the Zhou, the Han, and the Six Dynasties and began to develop recognizably modern ornamentation. The ornamental subjects differed from the geometrical style of the primitive society and the realistic or imaginative animal-pattern lines of the Shang Dynasty, the Zhou Dynasty and the Six Dynasties. Inspiration was instead taken from plant shapes and natural scenes. This rich ornament was in harmony with the colorful techniques that were developed, particularly in ceramic, textiles and lacquer. There were many methods for applying glazes onto ceramics, such as glaze splashing, glaze flowing, base winding and glaze

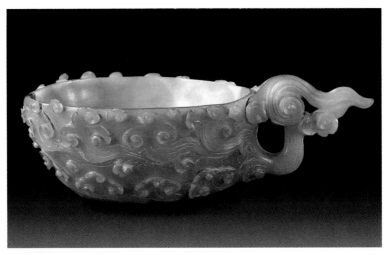

Jade cup in the shape of a cloud from the Tang Dynasty.

winding. In textiles, many methods were used to color and adorn silks, such as wax printing, twist printing (similar to tie-dyeing), clip printing, soda printing and rubbing printing; in lacquer ware mother-of-pearl inlays were popular, as were tracing a design in gold, placing fabrics between two layers of lacquer, and lacquer carving.

The Song, Liao, Jin and Yuan Dynasties (960-1368)

The Song Dynasty saw great advancement in arts and crafts, in terms of diversification, scale, technology, management and trading. The administrative systems of government-run handicrafts were more unwieldy and the system of division of labor more elaborate than in the Tang Dynasty. Most of the artisans working in government-run workshops had an increased degree of personal freedom while the management of the small folk craft workshop was even more flexible and open. The commerce of the Song Dynasty was well developed,

with a lively urban economy and large-scale commodity production. In Bianliang (the capital of the Northern Song Dynasty in the present Kaifeng, Henan) and Lin'an (the capital of the Southern Song Dynasty in the present Hangzhou, Zhejiang) there were shops and stores in great numbers, gathering together almost all articles for daily use, and urban handicrafts were flourishing. The scroll *Qingming Shanghe Tu* (*Pure Brightness Day on the River*), drawn by Zhang Zeduan (1085–1145) of the Northern Song Dynasty, shows the busy commercial activities in Bianliang city in a lively visual representation. There was a regular country fair on the outskirts of most big cities such as Chang'an, Luoyang, Fuzhou, Quanzhou, Yangzhou and Chengdu, and gradually the rural fairs developed into market towns.

A porcelain pillow from the Dingyao Kiln of the Song Dynasty, a rare piece of ancient porcelain exquisitely made in the shape of a vivacious child.

Three-foot *xi* (small vessel containing water for washing writing brushes) from the Ruyao Kiln in the Northern Song Dynasty, coated with smooth and lustrous cyan glaze both inside and outside.

The Song Dynasty deserved the title of the "Porcelain Age," as porcelain was the most outstanding of all its handicrafts. Famous kilns were scattered from north to south, the best known among them the Dingyao Kiln, Ruyao Kiln, Guanyao Kiln, Geyao Kiln and Junyao Kiln. They each created different ceramic varieties with their respective characteristics, such as the white porcelain of the Dingyao Kiln, the celadon of the Ruyao Kiln, the light greenish blue porcelain of the Guanyao Kiln, the crackle-glazed porcelain of the Geyao Kiln, the transmutation porcelain of the

Inscriptions on the underside

Jade ornament from the Jin Dynasty: flat in shape and partially purplish red.

Junyao Kiln and the shadowy blue porcelain of the Jingdezhenyao Kiln. In addition, the simple and straightforward porcelain fired by folk kilns like the Cizhouyao Kiln in the north and the Jizhouyao Kiln in the south was very popular among the people for daily use. In the Song Dynasty ceramics reached their zenith by incorporating the great achievements of the previous eras. The dyeing and weaving technology of the Song Dynasty was also greatly developed, with many varieties of silk weaving, particularly in the regions south of the Yangtze River. For the production of lacquer ware, not only did the government have special institutions, but their fabrication among folk people was also so common that local, more informal centers emerged. In jade carving, very high standards were achieved by working with the natural colors on the stone.

Due to the popularity of idealist philosophy in the Song Dynasty, the doctrine of "maintaining heavenly principles and restraining people's desires" was greatly emphasized. The technology of ceramics, lacquer ware, metalworking and furniture therefore worked with simple and unadorned shapes, avoiding over-elaborate adornment. In the Song Dynasty, the establishment of the imperial art academy system gave a crucial role to drawing, which had a direct impact on the fabrication of industrial art. For instance, drawing was the basis of embroidery and *kesi* silk craft. They became handicraft articles mainly created for enjoyment and were an important influence on the later industrial art of the Ming Dynasty and the Qing Dynasty.

In 1127, the troops of the Jin Dynasty went south and conquered Kaifeng, after which the royal family of the Song

Dynasty made Hangzhou the capital, and became known as the Southern Song Dynasty. Moving south, the imperial court of the Song Dynasty brought production technologies and skilled craftsmen from the north, stimulating the development of arts and crafts of the Southern Song Dynasty, particularly in textile printing and dyeing, shipbuilding, pottery, papermaking and printing. The rapid expansion in overseas trade under the Southern Song Dynasty also helped to promote the development of handicrafts.

During the Song and Yuan Dynasties, the handicrafts of national minorities were affected by the culture and handicrafts of the majority Han nationality. Important achievements from this period include Liao Porcelain, the gold vessels and silverware of the Liao Dynasty, the Jun Porcelain of the Jin

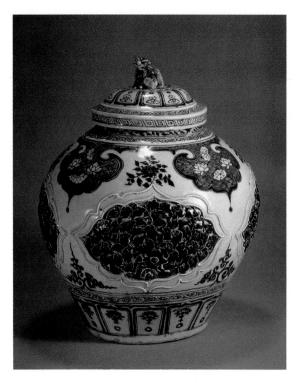

Carved blue-and-white underglaze red jar with lid from the Yuan Dynasty: simple and vigorous in shape and with a remarkable gradation of decorative patterns.

A gilded silver cockscomb pot from the Liao Dynasty, shaped like a typical leather bag of the Khitan people, its adornment, skill and line patterns are drawn from the traditional handicrafts of the inland region.

Lacquer plate with gardenia patterns by Zhang Cheng of the Yuan Dynasty.

Dynasty, the celadon and underglaze red ceramics of the Yuan Dynasty, and the dying and weaving of the Xixia Dynasty and the Yuan Dynasty. After founding its state, the Liao Dynasty developed the porcelain industry by setting up an official post to take charge of kiln business, mainly copying the porcelain system of the Dingyao Kiln, typically represented by a pot resembling a leather bag. In the later stage of the Jin Dynasty, new innovations in ceramic technology were made, particularly with the Jun Porcelain initiating the style of decorative porcelain with red spots in a cyan glaze. However, of all the handicrafts in the Xixia Dynasty, the fur industry was the most developed.

The handicrafts of the Yuan Dynasty suffered serious damage during its ceaseless wars. However, the Yuan made a point of recruiting artisans from prisoners of war for both military (in making weapons) and civic work. The status of artisans was hereditary, and they engaged in productive labor under surveillance.

Of all the handicrafts in the Yuan Dynasty, the achievements made in dyeing and weaving technology were the most important. A technique of weaving gold filament in silk fabrics

was the unique innovation of this period, represented by a kind of brocade called "nashishi." It was woven mainly for nobles' private use, but also as a gift or a reward. In this field, the artisans of the Hui nationality excelled. Cotton weaving was also universal as cotton fabrics, excellent in quality and reasonable in price, replaced the traditional fabric of bast fibers and became very popular. Huang Daopo (c.1245–?) of Songjiang, Jiangsu Province (now under the jurisdiction of Shanghai), made great contributions to promoting advanced techniques of cotton spinning and weaving.

Rulers of the Yuan Dynasty prided themselves on their bravery in battle. In their nomadic life, their love of hearty eating and drinking influenced the sturdy handicrafts of the era. Their thick, heavy, crude and large ceramic household utensils and splendid and impressive-looking silk fabrics were the typical expression of their style. The Yuan Dynasty also paid great attention to the dissemination of different religions, among which Buddhism and Taoism prevailed. In various kinds of handicrafts, religion was the most frequent subject. The expansion of territory and development of traffic in the Yuan Dynasty increased contacts among the various nationalities at home as well as exchanges with other countries, which promoted the dissemination and development of industrial arts as well as the absorption and influence of foreign styles.

The Ming and Qing Dynasties and the Republic of China (1368-1949)

The artisan system of the Ming Dynasty continued the hereditary system of the Yuan Dynasty, but artisans had more personal freedom.

In the Ming Dynasty many crafts developed further, and still-famous centers of specialist production emerged, such as Jingdezhen for pottery. Important Ming technologies include the

Yashou Bei (a kind of cup) during the Yongle period (1403–1424), celadon during the Xuande period (1426–1435), colored celadon and the *Ji Gang Bei* (another kind of cup) during the period of Chenghua (1465–1487), the mono-colored glaze during the period of Zhengde (1506–1521), and the export-oriented porcelain of Jiajing (1522–1565) and Wanli (1573–1619). The technology of

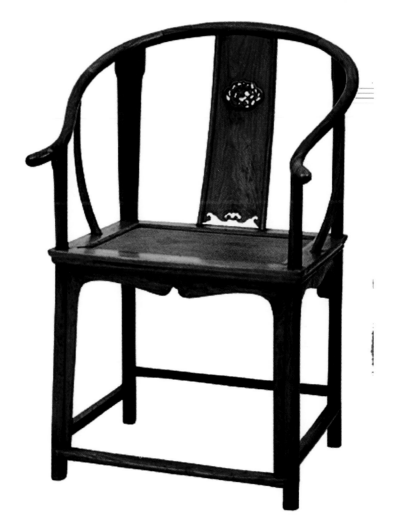

Round-backed armchair from the Ming Dynasty, well-proportioned in scale and lofty in shape.

dyeing and weaving developed by leaps and bounds in the Ming Dynasty, such as the silk weaving of Suzhou and Hangzhou, the cotton weaving of Songjiang, the printing and dyeing of Wuhu, and the embroidery of the Gu School in Shanghai. Metal handicraft was characterized by the *Xuande Lu* (a batch of small copperware cast with copper mined in southeast Asia for offering sacrifices to gods and ancestors as well as for laundering clothes) and cloisonné (a kind of enamel with a copper base and clipped copper wire). The fashion for garden buildings, the abundance of timber and the improvement of carpenter's tools stimulated the furniture making of the Ming Dynasty, which was known for its simple and unsophisticated shapes, perfect workmanship and refined style.

Gold crown from the Ming Dynasty, 24 cm high, woven from extremely thin gold filament, with two dragons vying with each other for a pearl on the top. It is one of the masterpieces of gold- and silverwork of the Ming Dynasty.

Numerous outstanding craftsmen came to the fore, such as Gong Chun and Shi Dabin, skilled in *Zisha Tao* (purple-clay pottery), Han Ximeng, who excelled at the embroidery of the Gu School, Madame Ding, skillful in cotton, Yang Xun, accomplished in golden lacquer, Lu Zigang, good at jade carving and the family of Zhu with their talent in bamboo carving.

In the Ming Dynasty, the new idealist philosophy "knowledge is action" put forward by Wang Shouren was very popular; other schools of thought emphasized erudition, practicality and science. In the later part of the Ming Dynasty, Wang Gen wrote "For common people, practical use is the correct way," which promoted the emergence of handbooks on arts and crafts. For instance, Huang Dacheng (a lacquer artisan of Xin'an, Anhui) and Ji Cheng (born 1579), a garden designer from Wujiang, Jiangsu, summed up their experiences and wrote the *Xiu Shi Lu* and the *Yuan Ye* (*Garden Design*) respectively. The *Tiangong*

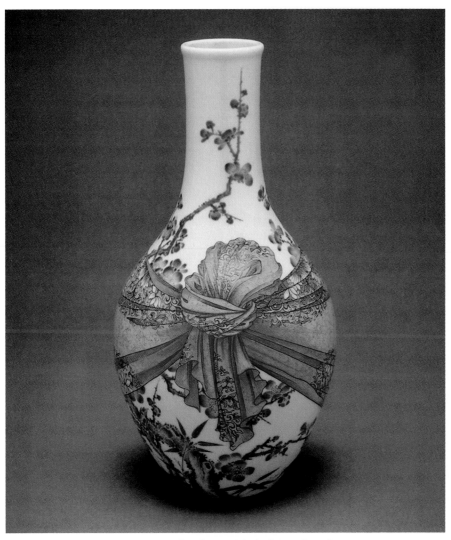

Multicolored blue-and-white vase from the Qing Dynasty (Musée Guimet, France).

Kaiwu, written by Song Yingxing (born 1587) is known as an encyclopedia of the arts and crafts in seventeenth century China, which summed up in a scientific way the processes of production and division of specialities of various kinds of handicrafts in the Ming Dynasty.

Zheng He visited the West seven times and promoted increased economic and cultural exchanges between China and other countries. In the later period of the Ming Dynasty, the seeds of a capitalist system of production appeared in the regions south of the Yangtze River. Western science and technology, for example in machinery and physiology, were steadily introduced into China by missionaries. These factors promoted the development of industrial art in the Ming Dynasty and a distinctive style in handicrafts, dignified, simple and decorative, was formed. Arts and crafts were still divided into those for the court and those for the people; the former more focused on perfecting technology; the latter more lively. The main features of modern Chinese industrial art as a national style began in the Ming Dynasty.

At the beginning of the Qing Dynasty, with the recovery of agriculture, handicrafts and commerce boomed. During the reigns of Kangxi (1662–1722), Yongzheng (1723–1735) and Qianlong (1736–1795), ceramics, dyeing and weaving, lacquer ware, and carving and engraving all advanced. In respect of ceramics, Jingdezhen was still the porcelain-making center, expert in firing technology and holding the most glaze varieties. During the Kangxi period, priority was given to ancient colors, and the style was vigorous and robust; during the rule of Yongzheng, colored porcelain was tasteful and delicate; and during the reign of Qianlong, enameled color porcelain was the greatest achievement, highly decorated and detailed. In dyeing and weaving, the silk and satin of Suzhou and Hangzhou, the cloud brocade of Nanjing, the brocade of Sichuan,

Enamel color and painted enamel

Enamel color is one of the ornamental skills applied to porcelain ware that originated from painted enamel technique. Porcelain using enamel color in decoration is also called "enamel color." It is actually an overglaze ornamentation applied to the porcelain base using painted enamel skills, which is called "guyuexuan" in China and "rose color" abroad. Enamel color started in the later years of the reign of Emperor Kangxi in the Qing dynasty and was further developed during the reign of Emperor Yongzheng.

According to historical records, the traditional process of painting enamel is to apply white enamel glaze on a copper porcelain base and then, after baking in the kiln to make the surface smooth, using an enamel glaze of different colors to paint ornamental patterns on the surface and baking it again in the kiln to make a finished product. The skill of painting enamel started in the middle of the fifteenth century in Flanders and was introduced to China in the seventeenth century. The painted enamel porcelain baked in China is sturdy and bold, similar to the mixed glaze on porcelain, whereas European painted enamelware is more thin and light in body with a strong glassy luster on the surface.

the textiles of Guangdong, the printing and dyeing skills of Shanghai, and the rugs of Xinjiang and Ningxia were known nationwide. Embroidery also formed local characteristics, with the embroidery of Suzhou, Guangdong, Sichuan, Hu'nan and Beijing the most famous. In metal handicraft, the Qianlong period saw further innovation in cloisonné, and by the end of the

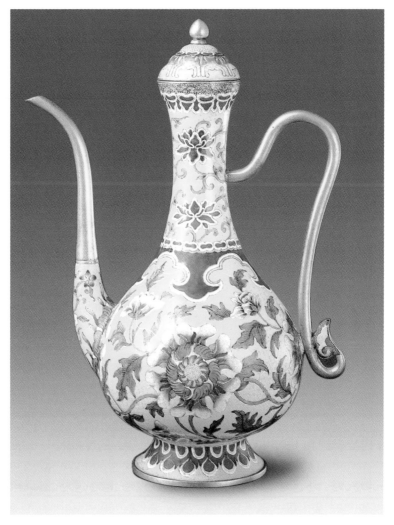

Painted enamel pot from the Qing Dynasty (Palace Museum).

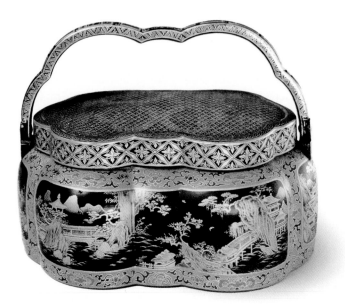

Portable lacquer hand-warmer with landscape patterns traced in gold from the Qing Dynasty (Palace Museum).

Qing Dynasty it had become an important commodity for export. Lacquer ware was made in fabrication centers with distinctive local features, such as the carved lacquer ware of Beijing, the lacquer ware of Yangzhou inlaid with mother-of-pearl, and the bodiless lacquer ware of Fuzhou. The painted clay figurine typical of the Qing Dynasty was represented by the artisan "Clay Figurine Zhang" of Tianjin and the clay figurines of Huishan, Wuxi. They were either made for practical use or used as toys, and were very popular among the people. Ornamentation was used to represent auspicious meanings through symbols, homonyms, metaphors and Chinese characters.

Following defeat in the Opium War (1840–1842), China was forced to open its doors to Western powers. With overseas commodities dumped on the Chinese market and China's raw materials plundered by colonial regimes, the self-sufficient economy of Chinese feudal society soon disintegrated. As a result, traditional Chinese handicrafts declined with a number of

craftsmen suffering bankruptcy, some even becoming destitute and homeless. However, during the period of the Taiping Heavenly Kingdom uprising (1851–1864), China's traditional handicrafts underwent some recovery and even growth, in particular in the trades of dyeing and weaving, metalworking, sculpture, and New Year pictures. During this period, craftsmen were held in high regard and the objects they made were valued for their usefulness. Arts and crafts were again organized and government policies encouraged innovation.

Influenced by Western material culture in recent years, Chinese traditional lifestyles and modes of production have changed and with them traditional arts and crafts. Following the import of overseas capital, machine production was introduced to China, causing traditional artisan skills to decline in favor of modern technologies adaptable to machine production. The court and aristocracy declined as a market for the finest products; the way in which traditional skills are handed down from master to apprentice and from parents to children also changed. During the late Qing dynasty, modern arts and crafts education based on school education, teaching both manual skills and technological knowledge, began to be developed in some missionary schools, industrial schools, and new schools appearing after the 1898 Hundred Day Reform, such as the Shanghai Tushanwan Arts and Crafts School established in 1864 by the French Catholic Church, the Hubei Handicrafts School founded by government official Zhang Zhidong (1837–1909), after the mode of Western technological schools, and the handicrafts department in the Nanjing Liangjiang Normal School founded in 1906 by artist Li Ruiqing (1867–1920).

The Revolution of 1911 overthrew the reign of the Qing dynasty, and was followed by the founding of the Republic of China in 1912. Former imperial workshops for manufacturing handicrafts soon disintegrated. Both court and folk artisans opened private workshops and stores, and gradually guilds were

Su (Jiangsu) embroidery *Portrait of Jesus*, 55.3x41.4 cm, made in 1914 by Shen Shou (1847–1921), representative of modern Su embroidery (Nanjing Museum). Dispatched by the Qing government, Shen Shou went to Japan in 1904 to study embroidery and painting. Back home he created "simulated embroidery," inspired by the use of light and colour in Western fine art. As her representative work, this portrait of Jesus was made using over a hundred kinds of color thread with light and colour ingeniously shown, the expression distinct, creating a three-dimensional effect. The work was awarded first prize in the 1915 U.S. Panama World Exposition. In 1914, Shen Shou was appointed Director of the Jiangsu Nantong Needlework School set up by the industrialist Zhang Jian. Shen wrote *Xuehuan's Embroidery Guidebook*.

New Year picture on a Shanghai calendar, *"Sitting alone lost in meditation,"* 62 x 42 cm, by Xie Zhiguang (1899–1978), 1931. The New Year picture on a calendar has a dual function of calendar and of decorative poster. The main part of the picture is a lady in a contemporary short-sleeved *qipao* (close-fitting woman's dress), wearing a wrist watch, sitting upright inside the moon gate. On both sides and on the upper part of the picture are advertisements for the Yongbei brand torch in both Chinese and English, below is the advertisement text for the 1931 Chinese and Western calendars.

established. The fine court objects made for appreciation in the past such as jadeware, ivory sculpture, cloisonné, and carved lacquerware, were now exported through overseas firms or bought by ordinary people. Handicrafts such as dyeing and weaving and ceramics, which were closely related to the people's livelihoods, had shifted to machine production. During World War I modern industries and commerce developed rapidly, with dyeing and weaving factories springing up like mushrooms. Meanwhile, traditional New Year pictures, advertisements, and packaging, also took on a new appearance influenced by modern Western design. One such example is the advertisements on calendars which, integrating traditional Chinese New Year pictures with modern advertisements, made their appearance in Shanghai in the late Qing dynasty and were prevalent in the 1920s and 30s.

But good times do not last long, as the saying goes. When the War of Resistance against Japan broke out in 1937, the market slumped, many people lost their livelihoods, and traditional handicrafts suffered severe damage. However, in the Liberated Area, to cope with the attack and blockade of the enemy, The Central Committee of the Communist Party of China launched the "Campaign for Great Production," calling on the people

to "get to work so as to live a life of plenty." Traditional handicrafts revived, in particular those closely associated with local military affairs, politics, the economy and daily life: dyeing and weaving, pottery and porcelain, glass, woodwork, knitting, packaging and embroidery.

In the Republic of China, arts and crafts developed further from where they had left off in the late Qing dynasty, stimulated by external exchanges: more and more students went to study abroad on state scholarships or at their own expense, and more and more people went abroad to attend international exhibitions. At that time, applied arts education in public and private schools of fine arts, handwork education in normal schools, and craft

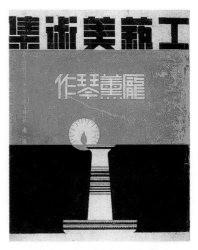

Cover of *Collection of Arts and Crafts*, designed by Pang Xunqin (1906–1985), 1941. In this book, combining modern design with past dynasties' ornamental patterns, he designed 30 articles of everyday use including a carpet, a tablecloth, a teapot and so on, elegant in style and with a distinct nationalist flavor.

education in industrial schools and vocational schools, had become the rising forces in the development of traditional arts and crafts. For example, Chen Zhifo (1896–1962), the first person to go to Japan to study arts and crafts, founded the Shangmei Pattern Center (1923–1927) when he returned to China. In this establishment, a large quantity of dyeing and weaving patterns were designed based on modern theories on arts and crafts. Others include Pang Xunqin (1906–1962), who studied modern arts in France and then applied arts back home, and published *A Collection of Chinese Patterns* in which he classified and studied ancient and folk decorative patterns using modern theory. In 1941, he published *A Collection of Applied Arts*, which contains patterns designed for household decoration. Arts and crafts education has gained new status and become more centrally important during the period of the People's Republic of China.

Materials for Daily Use

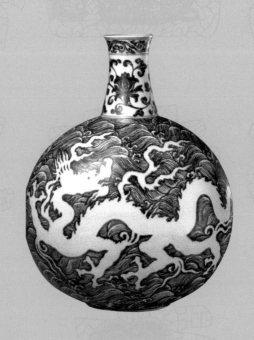

Ceramics

China is world-renowned for its ceramics, which has long been one of the most significant traditional handicrafts in China. As early as the early Neolithic Age 8,000 years ago, earthenware was being made and used. During the mid-Shang Dynasty, a rudimentary form of porcelain started to appear. Pottery and porcelain are both silicate products made at a different stage of development, porcelain being derived from pottery. They differ in raw materials, firing temperature and physical properties. Pottery was not phased out when porcelain was invented, but continued to develop on a course parallel to that of porcelain.

During the late Neolithic Age, painted pottery emerged in what is known as the Painted Pottery Culture, also known as Yangshao Culture, named after the village in Henan Province where pottery painted with colorful patterns was first discovered by archaeologists. Painted pottery is a kind of earthenware in

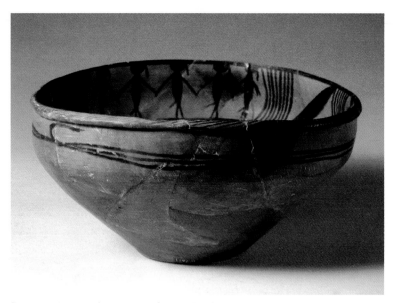

Painted earthen pot of the Majiayao Culture of the Neolithic Age (National Museum of China).

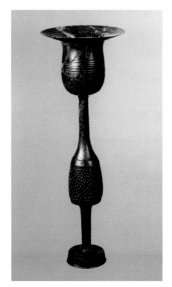

Pierced black earthen cup with a thin handle from the Longshan Culture (Shandong Provincial Museum). The thin tube joining three parts of the cup stays solid after baking, indicating the superb skills in pottery making at that time.

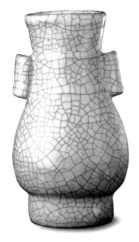

Double-ear jug of the Geyao Kiln (Palace Museum).

reddish brown or pale brown with elegant red or black decorative patterns. Painted pottery was distributed over a vast area, including the Yangshao Culture region, itself part of the Hemudu Culture, and the Dawenkou Culture region in the middle and lower reaches of the Yellow River (dating back to 4,500–6,400 years ago). As people tended to place their pots on the ground, the ornamental pattern tended to be most elaborate at the top while at the same time taking into account the vertical view and the side view in its effects.

Painted pottery eventually fell into decline and was replaced by black pottery originating in the lower reaches of the Yellow River and the eastern coastal area. The Black Pottery Culture is also called Longshan Culture, as remains of this culture were first discovered in Longshan, Shandong Province. By this time, black pottery was made in a new process using wheels, which resulted in a perfectly round and neat shape and even thickness, and which made possible greatly increased productivity in making pottery. Meanwhile, kiln sealing had been discovered and the structure of the pottery kiln was improved. The flame mouth was made smaller and the combustion chamber deeper so that a higher temperature could be reached within the kiln chamber. Black pottery wares were jet-black in color, lightweight and bright on the surface. String handles or ear-shaped handles were easily attached. Though the dark color made

the black pottery hard to decorate, artisans made up for this with beautiful shapes.

The first porcelain appeared in the Shang Dynasty; it was covered with a dark green glaze slightly tinged with yellowish brown. The treatment of the material was rough and preparation for the clay base crude. By the late Eastern Han Dynasty, porcelain production matured as specialized kilns for baking porcelain emerged in Zhejiang Province, which became a center of celadon production. Celadon ware spread from there to become widespread by the Six Dynasties Period.

By the late period of the Northern Dynasties, the successful development of white porcelain had started a new era in the history of Chinese ceramics. During the Sui and Tang dynasties, China saw an unprecedented flourishing in politics, economy, culture and commerce, which carried forward the progress of porcelain manufacturing, and expanded the porcelain market. Celadon was mainly manufactured in the southern part of the country, represented by the typical variety baked in the kiln of Yue, featuring a light and thin shape, a fine and close texture, and a smooth and sleek feel. Snow-white porcelain, represented by the kiln of Xing in the north, was characterized by sturdiness and compactness. The pottery of the Tang Dynasty, distinctive in its rich colors and wide variety of practical uses, from household articles to funerary objects, is known as Tang Tricolor.

In the Song Dynasty the well-known kilns gradually formed six major schools, each with their unique features: the Ding Kiln (in present-day Quyang, Hebei Province), Yaozhou Kiln (in Tongchuan, Shaanxi Province), Jun Kiln (in Yu County, Henan Province),

Tang Tricolor
Tang tricolor is the general name given to color pottery that has a varied glaze, used for practical or ornamental purposes and also on funerary objects. Tang tricolor, while it can contain various colors including green, blue, yellow, white, reddish brown, and brown, is mainly composed of yellow, green and reddish brown, hence the name.

With respect to pattern design, there are three varieties of Tang tricolor: figures, animals, and utensils. Figures represented include civil officials, military officers, aristocratic ladies, valets, maidens, artisans and people from different ethnicities; for animals the most common include horses, camels, cattle, sheep, lions, and tigers; for utensils there are containers, stationery, indoor appliances, and so on. Tang tricolor is mainly manufactured in Luoyang and Xi'an and in some regions of the Henan and Shaanxi provinces.

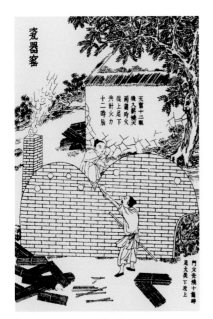

Porcelain kiln of the Ming Dynasty, an illustration in *Tiangong Kaiwu* (*Exploitation of the Works of Nature*).

Cizhou Kiln (in Ci County, Hebei Province), Longquan Celadon Kiln (in Longquan, Zhejiang Province) and Jingdezhen Kiln (in Jingdezhen, Jiangxi Province). At this time, porcelain dippers were widely used as teacups, with black glazed ones especially favored.

Chinese ceramic crafts entered a new stage of development during the Yuan, Ming and Qing dynasties. Mould-making became diversified, glazes shone with the brightest colors and decorations were resplendent. Painted porcelain, then widespread, was divided into two kinds: overglaze and underglaze. In underglaze porcelain the clay is painted before it is coated with a transparent glaze and then fired at a temperature of 1,300°C, giving a soft, tasteful effect. Its color, under the protection of the glaze, tends to be very fast. However, as only a few pigments can withstand the high temperatures, variety is limited. Underglaze porcelain originated in the Tang Dynasty in the Changsha Kiln. From the Song and Yuan dynasties onwards, quite a number of new varieties appeared including the underglaze red and the famous blue-and-white.

Overglaze porcelain is prepared by painting on glazed porcelain wares already fired in the kiln and then firing them again at a lower temperature. Such porcelain is rich in color, as more coloring materials can be found that can stand the temperature required in the firing process. The downside is that the color is susceptible to friction or erosion by acid or alkaline, causing damage like the color fading and changing. Overglaze porcelain started in the Ci Kiln during the Song Dynasty. By

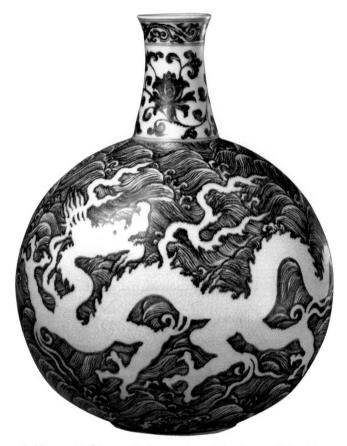

Blue-and-white porcelain flat vase with dragon pattern of Ming Dynasty (Palace Museum).

the Ming Dynasty, single-color overglaze and multi-color glaze techniques had already been fully developed. By the Qing Dynasty, more overglaze varieties were invented, such as ancient color, enamel color and mixed color.

In the Yuan Dynasty, blue-and-white porcelain and underglaze red porcelain each had distinguishing features. Jingdezhen, the porcelain capital, rose to prominence, with blue-and-white porcelain the most typical of its products. This type of porcelain uses metal elements such as cobalt salt as a coloring

agent to paint blue flowers on a white background. As only one color is used and one firing needed, the process is simple and easy and is therefore extensively used in porcelain decoration. Moreover, the plain yet elegant effect, achieved by using different mixes of blue color, was highly popular and admired and has been one of the most important varieties of porcelain ever since the Yuan Dynasty. Its subjects for decoration are largely taken from traditional wash painting, or they may include historic figures, tales and legends, taken from dramas and novels popular at that time.

Underglaze red porcelain gets its name from the red color under the glaze. Its color glaze effect was formed naturally at first, but became an artificially decorated variety later on. The blue-and-white underglaze red is commonly called "blue-and-white plus purple," characterized by patterns of fruits and flowers painted amid the blue-and-white patterns. It was one of the outstanding examples invented by Jingdezhen in the Yuan Dynasty, well-known for its magnificent colors, and has always been regarded as a rare variety of ancient Chinese porcelain owing to the great degree of difficulty in baking.

In the Ming Dynasty, porcelain craft achieved a breakthrough when bamboo tools were replaced by a potter's wheel in shaping clay, and dip-glazing was replaced by blow-glazing, thus enhancing both quality and quantity in porcelain manufacturing. With rapid progress in economy and transportation, a large number of imperial kilns and private kilns were established, which satisfied the needs of the court and the everyday needs of ordinary households, as well as the export market. From the Ming Dynasty onwards, white porcelain prevailed. Jingdezhen was still the center of porcelain making in the country, whereas the celadon of Longquan, the white porcelain of Dehua and the purple-clay pottery of Yixing were also known at home and abroad. Among them the porcelain Buddha sculptures made of

Dehua white porcelain were the most characteristic, and purple-clay teapots remain popular.

During the Qing Dynasty, glaze coloring increased in variety, such as red glaze in the Kangxi period (1662–1722), jasper glaze and rouge-water glaze in the Yongzheng period (1723–1735), and multicolor glaze comprising red, blue, green, yellow and purple in the Qianlong period (1736–1795). In color painting, ancient color, mixed color and enamel

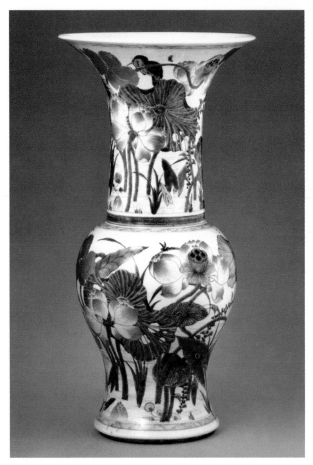

Qing-dynasty multicolored flower-and-bird *zun* (wine vessel) from Jingdezhen (Palace Museum).

color painting achieved a higher level of skill. Ancient color was a major variety in the Kangxi reign, which succeeded the multicolor technique of the Ming Dynasty, appearing gaudy and rich with distinct shades of color. Mixed glaze started in the Kangxi reign but became fully developed in the Yongzheng reign, with a soft and elegant hue and neat and meticulous drawing. By the middle period of the Qing Dynasty, foreign coloring processes started to be used when Western decorative techniques spread to China. Enamel coloring, the first imported coloring material, was used in the Kangxi reign and by the Yongzheng reign foreign coloring agents were manufactured in China. In the Qianlong period, the manufacturing of enamel coloring porcelain reached its peak. The porcelain bodies were produced in Jingdezhen, and then transported to Beijing where they were painted and fired for the second time. Enamel colored porcelain is characterized by its transparent shiny surface. Apart from Jingdezhen as the center, porcelain production had almost spread to every corner of the country, with products sold not only at home, but exported around the world. The development of ceramics in the Ming and Qing dynasties still has a significant influence on Chinese ceramics today.

Bronze Ware

The making of bronze ware in China goes back to very early times. A bronze sword made from a single mould 5,000 years ago, unearthed at the site of Majiayao in Gansu Province, is the earliest bronze object discovered to date. Over several thousand years, Chinese craftsmen have formed a unique style of bronze making in their development of the technological process, mould-making and decorative patterns.

During the late years of the Neolithic Age, both bronze and stone were used. The artistic forebears of bronze ware can

be found in the stone artifacts, pottery and jade articles made in the late years of the Neolithic Age. For example, the shapes of bronze implements and weapons originated mostly from stone equivalents, whereas the shaping of bronze vessels, tripods, cauldrons, and goblets was inherited from pottery mould-making. The distinctive *taotie* (a rapacious animal in Chinese mythology) pattern, a common decorative pattern on ancient Chinese bronze ware, can be traced back to jade articles made in the Longshan Culture in the Neolithic Age. The Erlitou Culture that came between the Longshan Culture and the Shang Culture had already entered the Bronze Age. The bronze ware found in Erlitou, in addition to tools, weapons and articles for personal adornment, includes vessels made with a double mould and a distinctive turquoise-inlaid technique.

Natural copper is reddish in color, hence the name *hongtong* (red copper). Bronze is an alloy of copper and tin, a bit bluish in color, and was hence called *qingtong* (blue copper). In his

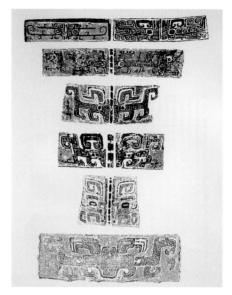

Rubbings of taotie patterns.

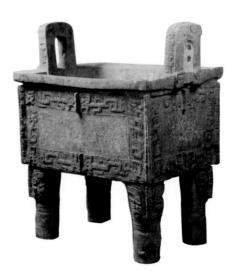

The "Grand Simuwu quadripod" from the late Shang Dynasty (National Museum of China).

Kao Gong Ji

Kao Gong Ji (The Records of Examination of Craftsmen) is the earliest book on handicrafts ever discovered in China. It explains the design norms and manufacturing processes of different kinds of handicrafts in the state of Qi during the Eastern Zhou dynasty. The book records a vast amount of data concerning manufacturing skills and techniques and a series of regulations for production management and construction, reflecting to a certain degree the ideology of the time. Most contemporary scholars believe that Kao Gong Ji is an official book of the state of Qi, a book giving guidance, supervision and examination to handicraftsmen employed by the government. The author of the book was a scholar at the Jixia Academy of the state of Qi.

Though limited in length, Kao Gong Ji contains extensive and invaluable information on a range of topics including cart-making, weapons, ritual objects, bells, silk dying, construction, water reservation, and more. The book also covers what was then known about astronomy, biology, mathematics, physics, and chemistry. Occupying an important place in the history of science and technology, arts and crafts and culture in China, Kao Gong Ji was a unique book in the world at that time.

Powerful Nation, Xunzi summed up bronze-ware making of his time as "moulds standard, materials fine, skills consummate, heat-control appropriate." The process includes extracting metal from ore, making a mould, casting, and technical improvement. As bronze manufacturing developed, cold hammering was replaced by casting, and the use of a single mould replaced by a double mould, which signifies a great leap forward in bronze technology. There are two categories of mould making: the pottery-mould approach and wax-slip approach. In a pottery mould, two moulds, the inner and the outer, are made with clay, the distance between the inner mould and the outer mould being the thickness of the body wall of the bronze object. In the wax-slip approach the body is made of wax which is covered with fine wet clay of a certain thickness, and then when the clay mould is dried, the wax is heated until it melts and flows out of the mould, after which the melted bronze is poured in. The wax-slip approach was initiated in the Spring and Autumn Period, and has been used ever since in making complex bronze wares.

The book *Kao Gong Ji* (*The Records of Examination of Craftsmen*) states that the formula for compounding bronze contains six raw materials. This is the earliest written text in the world to give the composition ratio of the alloy used in making bronze ware. Bronze ware has the advantage of a low melting point and great solidity and strength. Different bronze objects often have different ratios of alloys. For instance, in making bells or tripods, the proportion of copper to tin should be five to one,

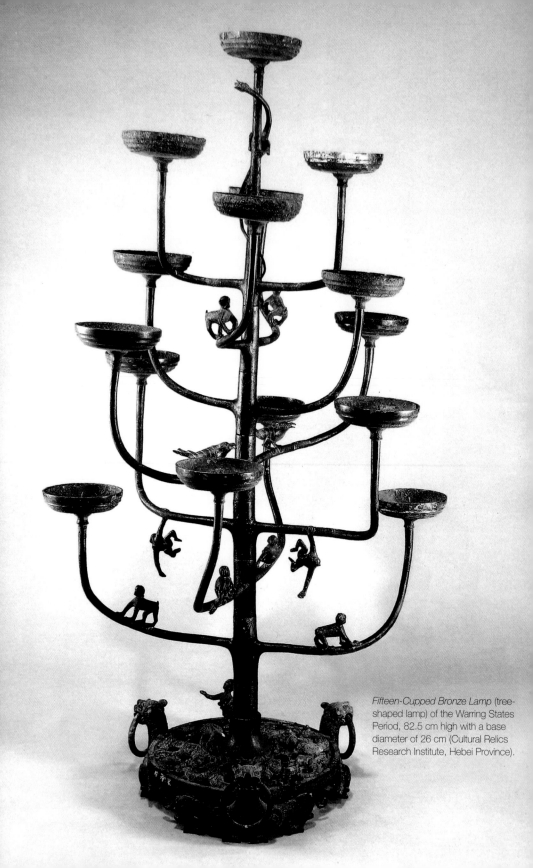

Fifteen-Cupped Bronze Lamp (tree-shaped lamp) of the Warring States Period, 82.5 cm high with a base diameter of 26 cm (Cultural Relics Research Institute, Hebei Province).

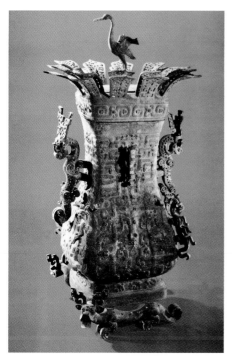

Lotus-and-crane square pot of the Spring and Autumn Period, 118 cm high, 30.5 cm in diameter (Palace Museum).

and in making axes, four to one. With such proportions, bells and tripods can be bright in color, and axes tough and tensile, the materials matched to the object's purpose.

The late years of the Shang Dynasty reached the first peak of China's bronze ware development, with the Yin Ruins of Anyang, Henan Province the center of bronze ware production. The early bronze articles were simply decorated, most single layered; later objects were meticulously adorned with multi-layer figures featuring an over-elaborate style. The decorative patterns on Yin and Zhou bronze ware are for the most part imaginary mythical animals reflecting the Shang people's faith in ghosts and deities, and the fact that bronze ware was mainly used in offering sacrifices. The most commonly used design was the *taotie*-pattern, characterized by a beast head with the straight bridge of its nose as a center line to form a symmetrical figure. Often large-sized objects were cast in the Shang Dynasty, of which a typical example is the celebrated *Simuwu Dafangding* (Grand Simuwu Quadripod). It is 133 cm high and 78 cm wide, weighing 874 kg, the biggest bronze item ever cast at that date. On both sides the faces of beasts and *kui* (a dragon-like monopod animal in ancient legends) are applied to adorn the edge, with the rest left unadorned so as to produce an artistic effect of contrast. The quadripod is an impressive, powerful

object, dignified and magnificent. The image of Grand Simuwu Quadripod often appears as a symbol of ancient Chinese civilization. So heavy is the vessel that it had to be cast upside down, with the four legs upwards. The ears of the vessel are hollow, made using a joining-cast technique. The work was done by at least two hundred craftsmen working in close cooperation, assisted by workers in charge of transport and burning charcoal, making a total of up to three-hundred artisans. It is thus clear that the bronze technology of that time had achieved a high level of skill and was capable of large-scale manufacturing.

During the Spring and Autumn Period and up to the end of Warring States Period, the application of bronze ware had shifted from offering sacrifices to daily household needs. Small objects for practical use were more and more favored by users and new practical functions were added to the original articles. Take the tripod made in the late years of the Spring and Autumn Period for example, in which the three ring-ears on the lid enable the lid to be used as a plate when overturned. The subject matter for decoration gradually lost its supernatural atmosphere as traditional animal designs turned into abstract geometric figures, and more realistic themes reflecting social life such as feasting, hunting, and war were added. Outstanding bronze pieces from this period include the "Square Pot with Lotus and Crane Design," with dragon-shaped ears, beast-shaped legs, and a lid with two layers of lotus petals that spread outwards, in the middle of which stands a crane with wings spread as if ready for flight; and the "Fifteen-Cupped Bronze Lamp" from the Warring States Period, discovered in the Zhongshan State (Hebei Province), which has a lamp pole shaped like a tree trunk, installed with fifteen small cups, with several monkeys in different shapes set here and there on the trunk (see illustration).

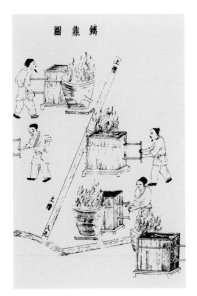

Casting tripod, an illustration in *Tiangong Kaiwu* (*Exploitation of the Works of Nature*).

During the Spring and Autumn and Warring-States Periods, bronze ware manufacturing reached new heights: not only were the separate-casting method and wax-slip casting method invented, but new crafts and new techniques were also adopted, such as welding and inlay, making bronze ware more rich and colorful. In particular in the later years of the Warring States Period, the use of sharp iron tools allowed the ornaments on bronze ware to develop from engraving designs to scratching, by which means a line can be as thin as a hair. By applying the technique of gold and silver inlaying, copper, gold and silver wire, or gold and silver slices, were inlaid to form various delicate patterns. The "Yanyue Yulie Gongzhan Hu" (a flask decorated with scenes of a banquet and music, fishing and hunting, attacking and fighting), excavated at Baihuatan in Chengdu in 1965, is a representative work of gold-inlay technique. Dividing the flask into "belted" sections to display various scenes such as mulberry picking, shooting, hunting, music playing, attacking and defending, and dividing each layer of designs with consecutive triangle patterns, the whole composition is diverse and yet unified in style. After the Warring States Period, with the development of iron-smelting techniques, improvement of ceramic technology, and the rise of lacquer ware, bronze ware gradually faded out of the mainstream of traditional Chinese technology.

Although bronze-ware manufacture declined gradually, the making of bronze mirrors as a unique variety of bronze technology continued its development for several centuries. The

bronze mirror was not only used, as today, in dressing and making up, but also ritually to reveal monsters and ward off evil spirits. From the Warring States Period through the Han and Tang Dynasties down to the Song Dynasty, highly decorative bronze mirrors were made. In the Tang Dynasty bronze mirrors were widely used as gifts. According to *The Book of Tang: Records of Ritual and Music*, the birthday of Emperor Xuanzong of the Tang Dynasty was designated

Suanni (legendary beast of prey) square mirror with grape patterns, length 17.1 cm, (Shosoin Repository, Nara, Japan).

"Eternity Day," on which officials were expected to dedicate birthday wine and mirrors were used as gifts to congratulate the emperor on his birthday. Such a practice facilitated the development of the bronze mirror, which resulted in a highly ornamental and colorful style. Popular ornamental patterns used on mirrors were the four deities of the heavens, the twelve zodiac signs, auspicious animals, flowers, birds, figures and the Eight Trigrams, used in ancient Chinese divination.

Among the bronze horses discovered in Wuwei (Gansu Province) in 1969, the one named "Steed Treading on Flying Swallow" is the most extraordinary. It shows a steed galloping ahead holding its head high, its tail thrown up, three feet rising into the air, the right hind leg stepping on a flying swallow (see illustration). The bronze lamps of the Han Dynasty were varied in style, all exquisitely made and in conformity with scientific principles, among which the finest example is the Changxin

Palace Lamp excavated at Mancheng (Hebei Province), in the shape of a maid in an imperial palace in a half-kneeling, half-sitting posture, her left hand holding a lamp, her right hand carrying the lampshade, with a sleeve serving as a siphon allowing oil to flow into the lamp body. The round lamp body has two tile-shaped movable shades, which can be used to regulate the direction of light. This exquisite object exemplifies the Chinese tradition of the combination of practical use and good taste.

Lacquer

In lacquer ware, which has a long history in China, color varnish is applied to a (commonly) wooden body. To date, the oldest piece of lacquer ware known is a lacquer-painted wooden bowl discovered in the Hemudu remains in Yuyao, Zhejiang Province, in 1978, which is around 7,000 years old.

Bronze galloping steed, also known as steed stepping on the flying swallow, from the Eastern Han Dynasty, 34.5 cm x 45 cm (Palace Museum).

Lacquer was invented in the Neolithic Age, and from the Xia, Shang, and Western Zhou dynasties down to the Spring and Autumn Period, lacquer ware was developed further. During the Warring States Period and the Han Dynasty, tree cultivation started to be taken seriously, which was conducive to lacquer production on a grand scale, which lasted for centuries. *The Classic Historical Records* states that Zhuangzi (c. 369–286 BC), the great philosopher, was once an officer in charge of lacquer affairs. In the Han Dynasty, a special government administration was established to take charge of lacquer production, which like other trades was managed under strict central organization with an elaborate division of labor. The inscriptions on Han Dynasty lacquer utensils excavated in Rakrang in Korea in 1932 reveal in detail the date, location, division of work and names of officials involved in the manufacturing. According to the records, the division of labor

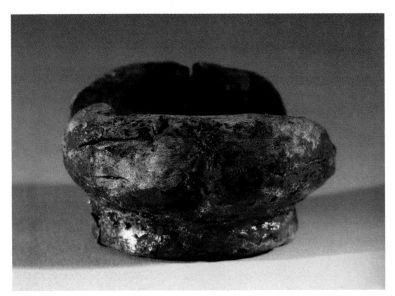

Vermillion wooden bowl from the Hemudu Culture (Zhejiang Museum). The earliest lacquer ware discovered so far, coated with a thin layer of natural vermillion lacquer on the surface, slightly lustrous.

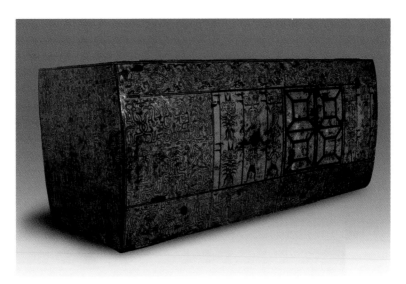

Painted lacquer inner coffin made in the early Warring States Period, found in the Zenghouyi tomb in Suizhou, Hubei (Hubei Museum).

was clearly demarcated, as lacquer body preparing, lacquer coating, painting, bronze buckle fixing, and finishing were done by specialized craftsmen. In addition, there were workers specializing in providing materials.

In the early Warring States Period, lacquer ware was made of thick and heavy wood. Later on, other materials were adopted including lightweight wood-chips, composite materials (gray ash generated from sumac and reinforced with flax fibers), and tough ox-hide. The State of Chu was the hub of lacquer production at that time; the articles made there were red and black in color, mostly red patterns painted on a black background with primitive simplicity. Animal patterns, geometric figures, and patterns reflecting social life such as chariots, horses, dancing and hunting were used for decoration. Lacquer ware was used for all sorts of material goods: not just utensils, stationery, ornaments and furniture, but also musical instruments, weapons and funerary

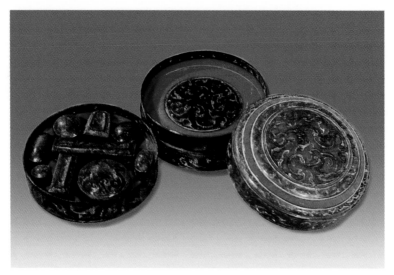

Double-layer lacquer case from the Western Han Dynasty, found in Han tombs at Mawangdui, Changsha. It contains nine smaller cases different in size and shape for various uses.

objects, in some cases instead of bronze ware. Lacquer goods were more expensive, but much favored by dukes and princes.

Building on the development of the Warring States Period, the scale and geographical spread of lacquer craft grew in the Han Dynasty, centered on the Shu and the Guanghan prefectures of Sichuan Province. Now larger but lighter artifacts were made, as techniques advanced. Examples include a lacquer bell 57 cm high, decorated with a pattern of clouds, and a lacquer plate 53.6 cm wide decorated with clouds and dragons. Increasingly complex objects were constructed, such as multi-latticed cassettes containing as many as nine or even eleven lattices different in size and shape.

Progress in lacquer manufacture slowed somewhat in the Eastern Han Dynasty, though not without some noteworthy results. In the Tang Dynasty, the gold and silver craft was a marked achievement. The process was first to have thin silver and gold sheets made in the shape of characters, birds, animals,

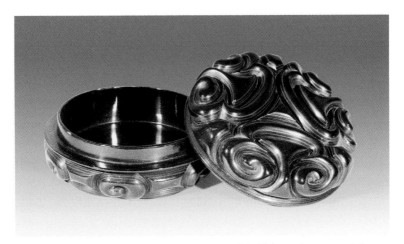

Lacquer box with cloud pattern from the Yuan Dynasty (Anhui Museum), a representative work by Zhang Cheng, master of lacquer-making.

flowers, and so on, which were then affixed to a smoothed lacquer body. Then two or three layers of lacquer are applied on the body when it is dried, then the body is sanded until the gold and silver patterns appear. Lastly the product is given a final polish. Lacquer articles made with this technique were highly prized, though costly and time-consuming to create. It is recorded in the ancient books *Miscellaneous Notes of Youyang* and *Deeds of An Lushan* that Emperor Xuanzong of the Tang Dynasty and his concubine Yang Yuhuan had bestowed to his official An Lushan lacquer articles manufactured using this craft. In the Song Dynasty the gold inlay technique was initiated, in which patterns are carved out on the surface of the lacquer and filled with gold powder. At that time, lacquer ware was produced not only by government artisans, but also by ordinary people. In the masterpiece painting *A Pure Bright Day on the River*, one can see a private-run lacquer store in Kaifeng, then the capital of Northern Song Dynasty.

During the Yuan, Ming and Qing dynasties, a new upsurge in lacquer-ware production arose, both in governmental and

non-governmental companies. The carving paint technology had achieved brilliant results in which fluid and smooth patterns were formed on thickly spread lacquer using a special cutting skill. In the Ming and Qing dynasties, lacquer technology, combined with architecture and furnishings, turned from the sphere of practical use towards ever more elaborate adornment, producing some four-hundred varieties under fourteen major categories including overspreading, tracing-designs in gold, and carving-inlay.

During the Yongle Period (1403–1424) of the Ming Dynasty, a lacquer-making institution called Guoyuanchang was established to serve the royal court exclusively; it produced two exquisite kinds of lacquer, by carving paint and by inlay. At the same time, production among the common people was also popular with a host of outstanding craftsmen active in this period, such as Jiang Huihui from Suzhou, expert at gold-lacquer, Yang Xun, who went to Japan to learn Japanese lacquer technology, and Zhou Zhu, who was skilled in the "hundred-treasure inlay" technique. Moreover, in the Ming Dynasty, the sole extant ancient book about lacquer technology, *Lacquering*, was written by Huang Dacheng, a master artisan in lacquer work from Xin'an (Anhui Province). In giving an account in detail of lacquer making procedures, materials, implements, color lacquer formulas, decoration methods, and more, it became a record of and a handbook for China's lacquer technology.

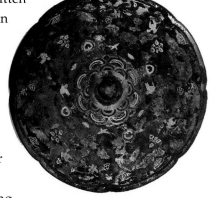

Tang-dynasty bronze mirror with silver background (National Museum of China).

Based on the achievements of Ming Dynasty lacquer work, a number of

Vermilion bodiless lacquer tray from the Qing Dynasty (Palace Museum). It is only about half a millimeter in thickness, with a hue of red coral.

manufacturing hubs appeared in the Qing Dynasty, each specialized in an individual variety with a local flavor, such as carving lacquer in Beijing, mother-of-pearl inlay lacquer in Yangzhou, and bodiless lacquer in Fujian. Tom Chippendale, the famous British furniture maker of the eighteenth century, even designed lacquer furniture using Chinese works for reference. The works he designed, adorned with patterns tinged with oriental appeal such as dragons, flowers, Buddhas, and pagodas, inspired the famous Chippendale style. The art of Chinese lacquer, as one of the significant varieties of Chinese traditional handicrafts, spread outwards to Asia and eventually to America via Western Europe.

Textiles

Embroidery

Embroidery in China goes back to ancient times. Some four-thousand years ago when China was passing from a primitive society to a slave society, there was a rule that when grand ceremonies such as celebrations and sacrifice-offerings were held, the tribal leaders should wear formal attire with patterns of the sun, the moon, and stars embroidered on the upper garment, and of plants, fire, and other patterns on trousers or skirts.

In the Spring and Autumn and the Warring States Periods, agricultural lifestyles solidified, with men doing the ploughing and farming work and women weaving. Mulberry and hemp planting, spinning and weaving spread extensively, and embroidery craft matured gradually. To date the earliest embroidery works still extant from ancient times are two pieces unearthed from the Chu Tombs in the Warring States Period. These pieces were made with the braid embroidering method (also known as locking embroidering) characterized by a neat stitch, flowing line and tasteful coloring, showing lifelike representations of a swimming dragon, a dancing phoenix, a fierce tiger and an auspicious monster embroidered on silks.

In the Qin and Han dynasties the development of silk-spinning increased the art of embroidery further. A diverse selection of well-preserved embroidered works was found in the Han tombs at Mawangdui of Changsha, Hu'nan Province. These embroideries, which represent the artistic style as well as the high skill level of embroidery in the Han Dynasty, mostly have patterns of ripple-like clouds, soaring phoenixes, galloping holy beasts, ribbon-shaped flowers or geometric figures, using the basic locking method with neat stitching, compact composition and smooth lines.

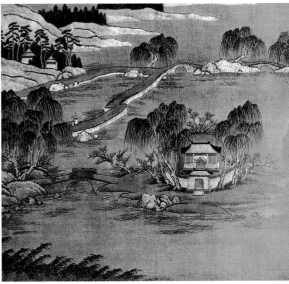

Flowery Brook – Fisherman's Retreat,
Ming-dynasty Gu-embroidered painting,
33.4 cm x 24.5 cm (Palace Museum).

"Orioles Singing in the Willows," from the Qing-dynasty Gu-embroidered
picture album *West Lake,* 24.1 cm x 26.3 cm (Taipei Palace Museum).

The prevailing practice of embroidering representations of the Buddha started in the last years of the Han Dynasty. During the Six Dynasties, foreign influences including Buddhism mingled with local culture, and this was reflected in embroidery. Some silk fragments from the Eastern Jin Dynasty down to the Northern Dynasties unearthed in Dunhuang in Gansu Province, and Hetian, Bachu, and Turpan in the Xinjiang Uygur Autonomous Region, reveal that the whole piece of work, both design and background, was closely embroidered using the locking technique, covering the fabrics completely with embroidery. In the book *Famous Paintings through the Ages,* Zhang Yanyuan, a Tang Dynasty writer, states that Lady Zhao in the court of the State of Wu was distinguished for her "three matchless skills" — matchlessness in weaving, in stitching and in silk. She was adept at weaving dragons and phoenixes on patterned brocade with

Qing-dynasty Suzhou embroidered cuff edge with 12 Chinese zodiac signs (detail) (Suzhou Embroidery Research Institute).

colorful silk thread; embroidering the Five Holy Mountains on a square piece of fabric; and making soft curtains with a specific kind of silk named Jiaoshu silk. Another notable feature of embroidery at that time was that human figures had started to appear on embroidered works.

Although the Han Dynasty locking-embroidery technique was still followed in the Tang Dynasty, another skill called the plain-stitching method was widely in use, together with some other stitching methods, using color thread and a wider range of fabrics. Patterns were edged with gold and silver thread to give a three-dimensional effect. During the Tang and Song dynasties, as more and more people became engaged in

embroidery, the representative needlework among women, "boudoir embroidery," emerged. At the same time, embroidery painting, which combines painting with embroidery, emerged, with designs contributed by painters and embroidery made by artisans. From the Tang down to the Ming and Qing dynasties, the participation of scholar-painters in the business had carried forward the innovation and development of embroidery techniques: in the treatment of color silk, thread was cut into finer pieces, so that the lines might appear more soft and graceful; in stitching methods, various new approaches appeared, such as arbitrary stitching, thread nailing, gold circling, mixing stitching, rolling stitching, and linking stitching.

In the Ming and Qing dynasties, the government-run handicraft business waned gradually. Non-governmental workshops started to arise, thus facilitating the growth of folk handicrafts. Thanks to cooperation between scholars and artisans, embroidery skills and production thrived. Traditional Chinese embroidery reached its summit of prosperity, with four

Qing-dynasty embroidered card folder from Guangdong, 24 cm x 39 cm (Palace Museum).

Qing-dynasty embroidered fan from Guangdong (Palace Museum). On a white satin background, an apricot grove and swallow are embroidered on one side and a peacock and a peony on the other.

famous schools of embroidery: Su-embroidery, Yue-embroidery, Shu-embroidery and Xiang-embroidery.

Centering on the city of Suzhou, Su-embroidery was developed on the basis of Gu-embroidery. Originally Gu-embroidery referred to the works done by the Gu family of Shanghai in the Ming Dynasty. Han Ximeng, wife to Gu Shouqian of the Gu family, was skilled at painting flowers and plants and in particular at embroidery, and thanks to her the fame of Gu-family embroidery spread far and wide. In the Qing Dynasty, embroidery shops in the region south of the Yangtze River often hung up the sign "Gu-embroidery" to solicit customers. Su-embroidery, having extensively drawn from the strengths of Gu-embroidery, created its own varieties including painting-imitation embroidery and portrait embroidery. Su-embroidery features perspective in landscape, depth in buildings, vivid portraiture and lifelike flowers and birds. In terms of technique, overlapping stitching is mainly used, in which floss and thread overlap without revealing any trace of stitching. Often three or four different kinds of thread either of the same color or of a similar shade are applied to produce a hazy effect.

Yue-embroidery, being the general name for embroidery in the Guangdong Province, is believed to have been initiated by the Li people (a minority nationality). Embroidery workers in former times were mostly men from Guangzhou and Chaozhou. Their embroidered works included primarily dress and adornments, hanging screens, shoulder bags, screen pictures, round fans, and fan cases. Decorative subjects include the phoenix, peony, pine and crane, deer, chicken and goose. The composition is usually elaborate, the coloring magnificent and dazzling, the stitching simple and concise. Rough and loose thread is used to make uneven stitches, some longer and some shorter, overlapping one another and slightly raised. The gold embroidery is of the best quality: it is made using a satin background knitted with

golden thread or golden floss, covered with loose golden floss design to give a resplendent effect. Works made using the gold-nailing technique include stage costumes, furnishings for theaters and temples to heighten a warm and animated atmosphere.

Shu-embroidery, also known as Sichuan embroidery, is an age-old local craft based around Chengdu in Sichuan Province. According to the book *History of the State of Huayang* written by Chang Qu in the Qin Dynasty, Shu-embroidery and Shu-brocade were the two specialties of Sichuan Province. Shu-embroidery works include quilt covers, pillow cases, garments, shoes and painted screens, mostly articles of everyday use. The designs are largely flowers, birds, insects, fish, auspicious folk sayings and traditional patterns. Since the middle and later period of the Qing Dynasty, on the basis of traditional local embroidery technique, Shu-embroidery took elements from Gu-embroidery and Su-embroidery and sprang up overnight to become one of most important commodity embroidery varieties in the country. Shu-embroidery features neat stitching with a smooth and bright quality, with clear lines, sumptuous colors, and a pattern-edge so sharp it looks as if cut with a knife.

Xiang-embroidery is the general name for embroidered works made in Hu'nan

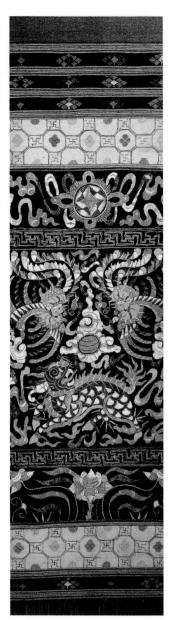

Qing-dynasty Li nationality embroidered dragon quilt. On a background woven from rough kapok thread is a 63 cm long frieze of phoenixes and Chinese unicorns.

Province, Changsha being the major hub. At first, merchants in Changsha set up a Gu-embroidery shop to cater for the newly appointed high official who rose to power by suppressing the Taiping Revolution. Soon their own local style had prevailed over Gu-embroidery. Xiang-embroidery is characterized by using silk thread to embroider flowers. The silk is treated in a certain solution to prevent it piling. Xiang-embroidery was locally known as "fine wool embroidery." Using traditional painting as its subject matter, Xiang-embroidery boasts a vivid and lifelike shape and unconstrained style, accurately praised as "flowers embroidered seemingly fragrant, birds embroidered seemingly chirping, tigers embroidered seemingly running and figures embroidered seemingly true to life."

Printing and Dyeing

Dyeing textiles using minerals and plant pigments is a time-honored practice in China. Early in the Neolithic Age, some six to seven-thousand years ago, the Chinese ancients could already dye sackcloth red with hematite powder. Through long-term practice in production, Chinese people had learnt the techniques

Eastern Han-dynasty blue-and-white flowery calico, 86 cm x 45 cm (Xinjiang, Uygur Autonomous Region Museum).

of dye-extracting and application to make the most colorful fabrics.

During the Shang and Zhou dynasties, with dyeing techniques gradually improving, government officials were appointed to take charge of dyeing, and they were known as "dyeing men" or "dyestuff keepers." In the ancient classic *The Book of Songs*, fabrics in various colors are mentioned, indicating an increasing diversity of available dyes.

Dyeing techniques reached a high level during the Han Dynasty. There were two major approaches: weaving before dyeing, as with *juan*-silk, silk gauze and damask, and dying before weaving, as for brocade. The brocades bearing the Chinese characters *"yan nian yi shou"* (meaning "prolonging life") and *"wan shi ru yi"* (meaning "everything going the way one wishes") excavated in 1959 from the Eastern Han tombs in Minfeng, Xinjiang, Uygur Autonomous Region, were woven with silk threads of diverse colors including crimson, white, yellow, brown, sapphire blue, pale blue, glossy dark green, dark reddish purple, pale orange, and light tan, manifesting the craftspeople's superb skills in dyeing and color matching. The Tang Dynasty silk fabrics unearthed in Turpan, Xinjiang Province, are still bright with as many as twenty-four colors. Quite a few assorted colors were obtained by first dyeing primary colors and then applying a process-dyeing method to create different hues.

The earliest printed fabric still in existence is the silk quilt cover buried in a Chu tomb in the Warring States Period

Batik works of the Bai people in Dali, Yunnan Province.

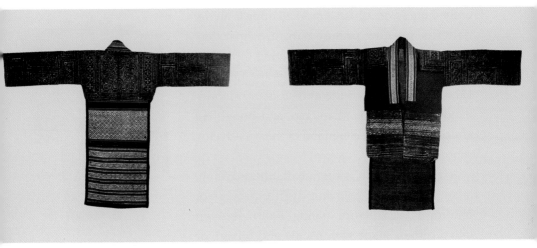

Qing-dynasty batik embroidered dress of the Miao people, view of front and back.

in Changsha, Hu'nan Province. Other pieces were discovered in Western Han tombs in both Mawangdui in Changsha and Mozuizi in Wuwei, Gansu Province. Among them was a piece of silk gauze with cloud patterns printed in gold and silver colors against a grey background. It was process-printed using relief printing plates, a rather advanced technique. Strangely, such techniques were not applied again in the several hundred years after the Western Han Dynasty. In the Central Plains, the revival of printing techniques started from *xie* (meaning valerian, here meaning wax-valerian craft). Later on *xie* was used as a general name for printed fabrics.

Printing and dyeing crafts became highly developed by the Tang Dynasty. Wax-valerian, tie-dye and clip knot were the three major printing processes used for fabrics in ancient China. Wax-valerian is also known as wax dyeing or batik. Patterns are drawn with wax on natural fiber fabrics such as hemp, silk, cotton, wool, etc. before dyeing. The wax prevents the dyeing solution from entering the patterns. By heating the fabrics the wax is removed and the patterns are revealed. The condensation and contraction

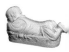

of the liquid wax causes cracks to appear on the patterns, forming unique natural veins. Wax dyeing as an age-old, dye-insulating technique can be traced back to as early as the Qin and Han dynasties, when the ancestors of minority nationalities such as Miao, Yao, and Bouyi had already had a good command of the wax-dyeing process.

Tie-dyeing, also known as ligation-dyeing, is an ancient folk printing-dyeing process of binding fabrics before dyeing. Fabric is sewn into a certain shape with needle and thread, or bound tightly with thread in accordance with the design so that the fabric becomes crumpled and overlapping. As the crumpled part will hardly take the dye, whereas the unbound part is easily dyed, a hazy effect is produced. In the Jin Dynasty, tie-dyeing started to spread among the people. During the Southern and Northern Dynasties, popular designs included white patterns on a purple background, thought to look like the skin of a Sika deer. By the Sui and Tang dynasties, tie-dyeing became all the rage. Currently the earliest ancient tie-dyed fabric known is the Jin Dynasty *juan*-silk unearthed from the Astana tomb in Xinjiang, on which both pinpricks and crumples are still dimly visible.

Clip-knot dyeing was in vogue in the prosperous period of the Tang Dynasty. In this process, fabrics are placed between twin pieces of wooden board and then dyed. Using this method the designs appear symmetric and

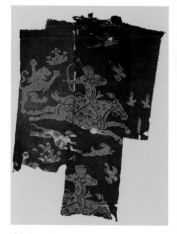

Valerian clip-knot *juan*-silk with hunting patterns from the Tang Dynasty, 43.5 cm x 31.3 cm (Xinjiang Uygur Autonomous Region Museum).

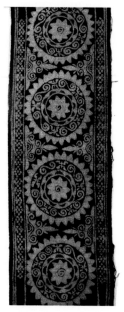

Qing-dynasty batik lace of the Bouyi people, handwoven in Guizhou and printed using traditional techniques.

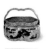

balanced. At that time, clip-knot was often used for women's dress and adornments, and sometimes as ornaments for furniture such as clip-knot screens.

Silk Weaving

Chinese silk weaving is known worldwide for its long history, advanced technique and fine workmanship. Silk fabrics in ancient times include the following varieties: *juan* (thin, tough silk), *sha* (gauze), *qi* (damask), *luo* (silk gauze), *jin* (brocade), *duan* (satin), and *kesi* (brocade woven in a special way).

In the Shang Dynasty, silk fabric with a conspicuous twisting warp weave had already emerged. By the Western Zhou Dynasty, a more complicated brocade-weaving craft was developed. In the Spring and Autumn and Warring States Periods, silk weaving had attained a rather high level, with *juan*, *luo*, *sha*, and *jin*; designs included a rhombus pattern, S-shape pattern, and geometric patterns adorned with dragons, phoenixes, and human figures. Silk weaving and knitting in the Qin and Han dynasties, the Han in particular, made a leap forward on the basis of the Warring States Period tradition, containing more varied silk fabrics such as *jin*, *ling* (twill-weave silk), *qi*, *luo*, *sha*, *juan*, *gao* (thin and white silk), and *wan* (fine silk fabrics). The common designs on silk fabrics of the Han Dynasty include floating clouds, animals, flowers and plants, auspicious characters, and all kinds of geometric figures. The art of silk-weaving in the Han Dynasty was elaborate, in particular in the weaving of single-thread gauze with evenly distributed meshes, of which the representative work is a plain gauzed Buddhist monk's robe found in Han Tomb No.1 in Mawangdui in Changsha, Hu'nan Province. It measures 128 cm across the two sleeves, is 190 cm long and yet weighs only 49 grams. Silk weaving in the Tang Dynasty operated by means of a meticulous division of labor. The Weaving and Dyeing Administration under the central government had been set up to

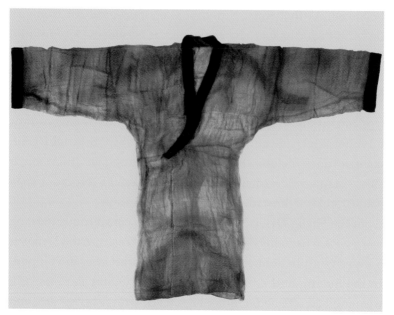

Monk's plain-gauze robe found in the Han tombs at Mawangdui, Changsha, Hu'nan Province. It is made of the finest natural silk, and demonstrates the quality of Chinese silk weaving at that time.

take charge of production, while private silk-weaving businesses could be found all over the country, also producing a large quantity of fabrics. Craftspeople at that time aimed at the most impressive coloring effects. Among multiple varieties, brocade was the best-known. Differing from the traditional craft in which the warp was used to weave decorative patterns, Tang brocade-weaving, influenced by the textile culture of the Western Region, used the weft to form decorative patterns sandwiched between the warp weave. This was called "weft brocade." The loom used for weft brocade by which decorative patterns are formed with multi-layer and multi-colored weft, is complicated in structure but easy to handle, capable of weaving more complex designs and wide fabrics. Since the middle period of the Tang Dynasty, using weft to form decorative patterns had become

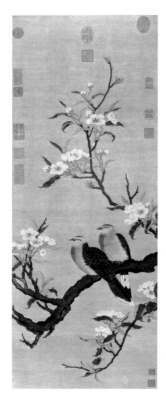

A silk painting by Shen Zifan, a *kesi* silk weaving craftsman, a fine example of the serene and realistic style of flower-and-bird painting of Southern Song Dynasty.

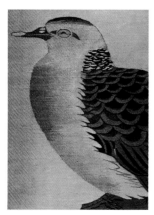

Kesi silk-weaving: scroll flower-and-bird painting by Shen Zifan (detail).

the mainstream in silk jacquard weave. Tang brocade assimilated exotic ornamental patterns. Aside from Tang brocade, *ling* (silk fabric with a twill weave as basic characteristic) was also very popular, in particular the *liao-ling* manufactured in Zhejiang Province, which was best known at that time. Dou Shilun, the most famous silk pattern designer, usually used animals like sheep, horses, dragons, and phoenixes for decorative patterns. His original, unconventional, and vital designs were known as "Duke of Lingyang patterns," after the title he was granted by the emperor.

In the Song Dynasty brocade weaving was further developed. Using three kinds of twill weave, two kinds of warp (raw silk for the surface and colored boiled-off silk for the base) and three kinds of colored weft, a regular and neat weave was produced in elegant and harmonious colors with small ornamental patterns. The Song brocade was used for dress and adornment, for reward and trade, and as a material for mounting pictures. At that time, *kesi* brocade was also very popular, used mainly for weaving works of art such as paintings and calligraphic works. It shows that the function of silk-weaving crafts had shifted from mainly practical use to ornamental and aesthetic appreciation.

Kesi silk was produced in Dingzhou, Hebei Province in the Northern Song Dynasty, and around the Yunjian area (now Songjiang of Shanghai) in the Southern Song Dynasty.

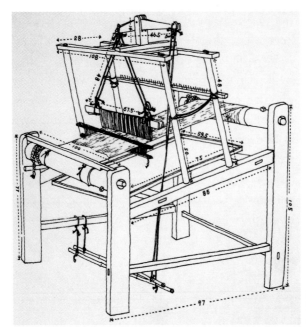

Kesi-weaving loom in Wuxian County, Jiangsu Province.

Between the Song and Yuan dynasties, a giant spinning wheel with several dozen spindles was invented as a development from traditional wheels. The wheel, driven with waterpower and able to adapt to large-scaled production, already had the rudimentary form of modern spinning machinery. Take hemp spinning for instance: an ordinary wheel could produce at most one and a half kg of yarn a day, whereas the giant wheel could make over fifty kg in twenty-four hours. It was a significant invention in ancient China, using natural forces for textile machinery.

Gold-weaving was unique to the silk-weaving art of the Yuan Dynasty. Yuan Dynasty rulers had a great partiality for gold, making gold weaving fashionable. The designs on golden brocade included dragons, phoenixes, flowers, tortoise shells, and *hui*-figures (a figure in the shape of the Chinese character *hui*). In order to suit the needs of the nomadic Mongolian nationality, wool weaving developed, mostly carpets, bed mattresses,

saddles, shoes and headgear, produced mainly in Ningxia and Helin. In ancient China, cotton was planted only in the northwest and southwest regions. Due to the work of Huang Daopo, a remarkable innovator of cotton textile crafts in the Yuan Dynasty who was a native of Wunijing, Songjiang (now in Shanghai), and cotton textile craft spread far and wide. For a time, the "Wunijing quilt" became well known throughout the whole country.

During the Ming Dynasty, four main silk fabric producing areas emerged: Shanxi, Sichuan, Fujian-Guangxi and the region south of the Yangtze River. At that time, brocade was the most typical kind of silk fabric and was made in three varieties: warehouse brocade, gold-silver brocade and flowery brocade.

Yuan-dynasty golden thread damask cape (Palace Museum).

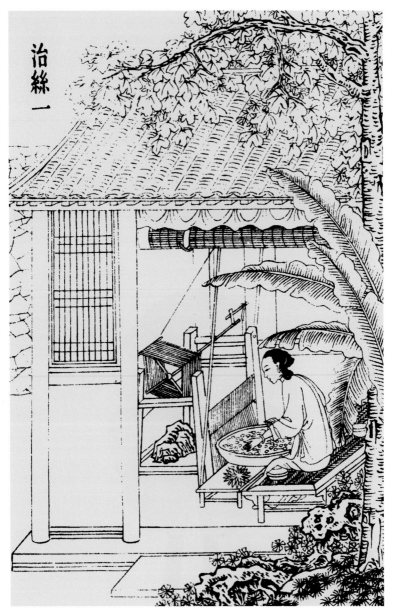

Silk-Reeling, an illustration in *Tiangong Kaiwu* (*Exploitation of the Works of Nature*).

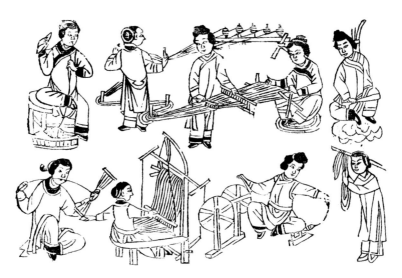

New Year picture: *Spinning and Weaving*, a scene of nine Qing-dynasty women at work: cotton fluffing, spinning, yarn starching and weaving.

Warehouse brocade features a soft and elegant grey coloring. Gold-silver brocade looks refined and glitters, with gold or silver thread used for weaving. Flowery brocade is a jacquard fabric, woven using a special shuttle-moving process to insert colored silk threads. Every single flower in the pattern is woven with different colors. The flowery brocade which first appeared during the Tang Dynasty and prevailed in the Ming and Qing dynasties represented the highest level of ancient Chinese silk weaving. Ming brocade can be divided into light gauze, silk gauze, and satin according to their different base-fabrics. It is rich in patterns, such as clouds, dragons, phoenixes, cranes, flowers, plants, birds, butterflies, and auspicious figures, with a stylized decorative beauty.

Suzhou, Nanjing, and Hangzhou were the major silk-weaving centers of the Qing Dynasty, well known for their rich variety and exquisite workmanship. At an early stage, the traditional features of the Ming Dynasty were inherited, in which geometric figures

were used as a framework, embellished with small flowers. In the middle stage of Qing silk development, influenced by the art styles of baroque and rococo from Europe, designs became more complicated and resplendent. At the later stage, simple, seemingly spontaneous broken-sprig and large flower patterns were in fashion. Besides Yunnan brocade, Song-style brocade and Sichuan brocade, famous fabrics of the Qing Dynasty also include ancient fragrance satin and brocade satin. Satin is a shiny and smooth fabric that appeared first in the Yuan Dynasty and became a mainstream silk fabric during the Ming and Qing dynasties.

Homewares

Furniture

Furniture reflects both life-style and environment. In ancient times, the Chinese people sat on the floor; later they began to use seats as they do today. The shape of furniture accordingly falls into two types, low and high, to suit people's needs at different historical stages.

From the Shang and Zhou down to the Han and Wei dynasties, people used to sit on the floor or take a half-kneeling, half-sitting position. The limited pieces of furniture available at that time such as narrow oblong tables and side tables were all low and short, and could be moved around easily. In the Three Kingdoms, a higher type of seat called *Hu-chuang* (literally "bed from non-Han areas"), similar to a present-day campstool, was introduced for the first time to Han people under the influence of the minority nationalities. As time went by, higher articles for home use, such as round or square stools, started to appear

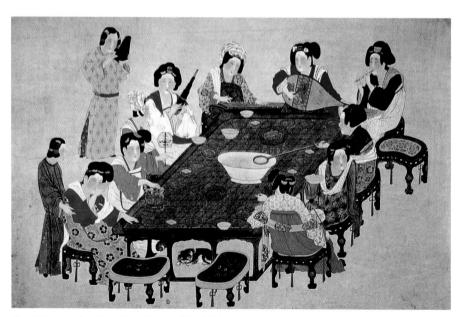

Court Music by Zhou Fang, Tang Dynasty (Taibei Palace Museum).

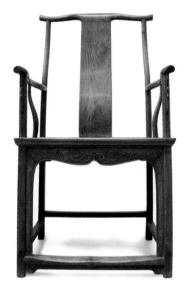

Ming-dynasty yellow rosewood mandarin-style chair, 116 cm high, named after its resemblance to an ancient official's headgear.

in the Central Plains. Beds and couches also gradually became higher, though low furniture still dominated. Starting from the Western Jin Dynasty, the concept of the half-sitting, half-kneeling posture, till then required by etiquette, gradually faded. People either sat on the floor with legs stretched out, or sat cross-legged, or sat aslant, just as they pleased. At this time the side-table was created, which was placed on the bed for leaning against or reclining, together with the *yinnang*, something like a modern back-cushion.

In the Tang Dynasty, people started to sit on seats instead of sitting on the floor. In the later years of the Tang, tables and

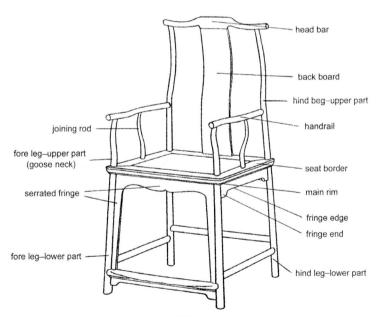

Structural drawing of the mandarin-style chair.

head bar

back board

hind beg—upper part

handrail

joining rod

fore leg—upper part (goose neck)

serrated fringe

seat border

main rim

fringe edge

fringe end

fore leg—lower part

hind leg—lower part

chairs appeared, alongside side tables, narrow tables, *xieshi* (an article developed from a side table used for leaning against), chests, cupboards, *Hu-chuang*, screens, and chessboards. Higher furniture such as tables, stools, and chairs became popular in the upper circles. By the Song Dynasty, all sorts of high-type furniture started to be widely used. In the Southern Song Dynasty, furniture attained a pinnacle in variety and shape, the workmanship becoming increasingly exquisite.

By the Ming and Qing dynasties, ancient Chinese furniture settled into a shape much higher than in the past. Ming-dynasty furniture is much admired as it is elegant, plain and ingeniously made. The rise of Ming furniture was closely associated with the social environment of the times, as the booming of cities and towns, the growth of the commodity economy and the blossoming of architecture increased demand for furniture. Moreover, in the Ming Dynasty, Zheng He, the great navigator, made seven trips to the West and the ban on maritime trade and relations with foreign countries was lifted, resulting in large quantities of timber being brought to China from South East Asia. At the same time, woodworking implements had been improved as never before. The book *Tiangong Kaiwu* (*Exploitation of the Works of Nature*) records that forging techniques were already highly advanced in the Ming Dynasty, and with it different kinds of woodworking implements were invented, for example different types of planes: pushing planes, thin-line planes and centipede planes, each used for different processes.

The Canon of Lu Ban compiled by Wu Rong, head of the imperial workman department under the Board of Works of the Beijing municipal government, is the only

Tiangong Kaiwu (The Exploitation of the Works of Nature), China's encyclopedia of arts and crafts in the seventeenth century
Authored by Song Yingxing (1587–1661), *Tiangong Kaiwu*, which was first printed in 1637 (under Emperor Chongzhen of the Ming Dynasty), is a comprehensive handbook of science and technology from ancient China. Widely translated, the book has become known worldwide as China's encyclopedia of arts and crafts in the seventeenth century. It offers a systematic summary of all kinds of technologies to form a complete system of science and technology. Many of the production processes recorded in the book have been in use up to modern times.

Tiangong Kaiwu is the first comprehensive work on agriculture and handicraft manufacture in which the production processes of brick-making, ceramics, sulfur, candle, paper, weapons, gunpowder, textiles, dyeing, salt-production, coal-mining, oil extracting, and machinery in particular, are narrated in detail.

extant specialist book on the building and repairing of wooden objects. The book sums up the designs and practices of master craftsmen over the centuries since the Spring and Autumn Period. Included in the book are over thirty designs for items of furniture in which measurements, tenon and mortise joints, end of lines and adornments are all given in detail, with pictures of the real objects attached. It is a significant reference work for the study of Ming-Dynasty folk architecture and Ming-style furniture.

In Ming-style furniture making, materials were chosen with great care. Usually hard wood such as red sandalwood or *huang-hua-li-mu* (a species of rosewood) was used, which, when polished with wax, reveals its natural grain and bright luster, fully in accord with the taste of the men of letters of the Ming Dynasty, who preferred primitive simplicity and elegance. In accordance with their hankering after natural things they preferred yellow woods to dark-colored woods, and *huanghuali* which is fine in grain, having the color of amber and the feel of jade, became the chosen wood for furniture-making from the late Ming Dynasty down to the early Qing Dynasty.

The most common tenon-riveting table structure.

Illustration in *Jin Ping Mei*, a classical Chinese novel.

Techniques used in furniture-making include: cutting open wood, sawing timber, planing, chiseling, drilling, carving, polishing, varnishing and waxing. The precise and ingenious process of fitting a tenon into a mortise to make a joint is a unique feature of Ming-style furniture, in which all joints are formed with a tenon and mortise structure without using nails or glue. There were many different kinds of tenon: open tenon, closed tenon, square-and-corner tenon, long-and-short tenon, swallow-tail tenon and so on.

Qing-Dynasty people tended to prefer dark colors to the natural yellow color of wood, as they were considered more luxurious. As the Qing royal family favored red sandalwood in particular, it became the first choice for making furniture. The articles still

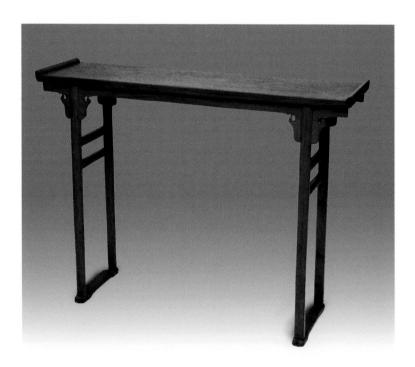

Ming-dynasty yellow rosewood side table, used to hold musical instruments (113 cm long, 27.7 cm wide, 83 cm high).

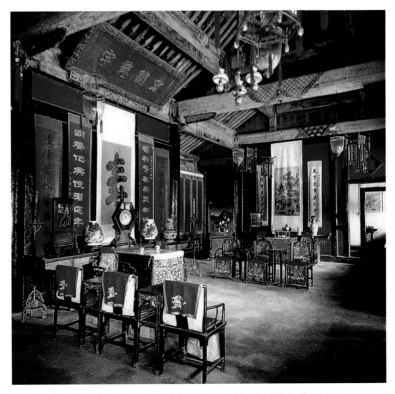

Furniture displayed in the back house of the Confucian Temple of Qufu, Shandong.

preserved from this period were mostly made for the court, and all meticulously carved. In the middle of the Qing Dynasty, *huanghuali* and red sandalwood were in extremely short supply and red wood started to be imported and widely used. Red wood is similar in quality to red sandalwood. While hard and impressive-looking, it is not tenacious enough to be easily carved and as it is susceptible to changing shape when affected with damp, dryness, cold, or heat, it is therefore unfit for detailed carving.

Ming-style furniture was notable for its exquisiteness within a plain shape while Qing-style is characterized by multifarious and elaborate decoration. Qing-Dynasty furniture-making reached the apex of traditional furniture crafts, with a combination of

97

traditional methods that also absorbed exotic influences to form a highly distinctive style.

By the Ming and Qing dynasties, traditional furniture had already diversified into all the varieties now known, which fell into six major categories: chairs (including stools); side tables; cupboards (or cabinets); beds (and couches); stands (racks) and screens. Types of chairs included the official-headgear-shaped chair, rose chair, lamp-hanging chair, round-backed armchair, folding chair, square stool, long stool, and drum-shaped stool. Tables included the *kang* (a heatable bed commonly used in North China), tea table, incense-burner table, writing desk, flat table, end-upwards table (table with both ends raised upwards), *jiaji* table (table on top of which a side table is placed), lute table, altar table, square table, Eight Immortals table (square table seating eight people), and crescent table. Cupboards included the cupboard-cabinet (combining the functions of cupboard, cabinet and table), *menhu* cupboard (table with drawers, somewhat similar to a chest of drawers), wardrobe, bookcase, treasure case, and treasure box. Beds included the framed bed and wooden couch. Stands included a coat hanger, basin stand, lamp stand, shelf for holding potted flowers, dressing table, and foot support. And screens included *chaping* (table screen with a stand), *Weiping* (folding screen, usually with four, six or eight folds), *luzuo* (stove base), and *huzuo* (pot base). Furniture of the Ming and Qing dynasties often used metals to further protect and reinforce the furniture, and to add luster as well.

Gold and Silver Ware, Glassware, and Enamelware

Gold and silver ware

The most important methods for processing gold articles originated from bronze-making and include smelting, mould founding, hammering, welding, bead-forming, engraving, wire-

drawing, wire-twining, and wire inlay. However, for gold ware all these were further developed or changed. Take bead-forming craft for example, an art unique to gold processing in which the first step is to let melted gold drip into warm water drop by drop to form beads of various sizes. Then, by welding each tiny drop of gold, fish-egg patterns or bead-string patterns are made. Silverware was developed later in history than gold, and followed gold articles in working procedures.

From the very beginning gold and silver articles were seen as works of art. The earliest extant gold objects were made in the Shang Dynasty more than 3,000 years ago. They were mostly ornaments, simple in shape and small in size, with basic decorative patterns. Shang-dynasty gold articles were chiefly gold and silver foil, gold leaves and sheets, used to adorn utensils; only rarely in the northern and northwestern regions were they used for personal adornment. Of the earliest gold articles, the

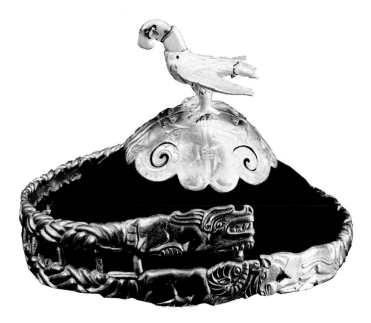

Eagle-decorated parts of a gold crown of the Warring States Period.

gold masks and the gold staffs unearthed from the early Shu-culture ruins in Sanxingdui in Guanghan, Sichuan Province, are the most eye-catching. In the Shang and Zhou dynasties, bronze techniques and jade carving facilitated the growth of gold and silver crafts.

The silver *chuwang yi* (ladle for dipping water in the shape of a gourd used by the king of the State of Chu), now in the Palace Museum, is one of the earliest silver utensils discovered so far. From the Spring and Autumn and Warring States Period, articles with gold and silver inlay are found in great quantity, which marked the high technical level of gold crafts at that time. The process of gold and silver inlay, one of the ancient fine metal techniques used for adornment, started from the mid-Spring and Autumn Period, prevailed in the Warring States Period and gradually declined from the Western Han Dynasty onwards. Patterns or inscriptions are incised on the surface of bronze ware

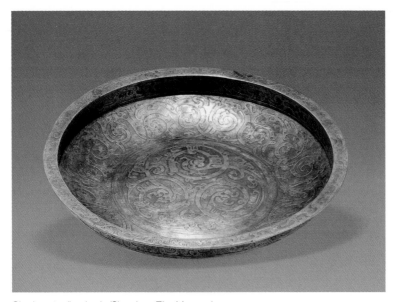

Qin-dynasty silver basin (Shandong Zibo Museum).

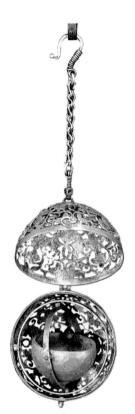

Tang-dynasty silver hollow ball-shaped incense burner. This is an ingenious device containing a perfume receptacle on an axle which always maintains the same orientation regardless of any movement of the supporting structure.

by casting or by chiseling, after which gold and silver wire are inlaid, and then ground and polished to produce a decorative effect.

In the Han Dynasty, gold and silver, in addition to decorating bronze and iron utensils using such techniques as coating, mounting, plating, and inlaying, were also applied to lacquer ware and silk fabrics by using foils or filings to increase splendor. Gradually the craft of using gold foil to make flower-shaped patterns was perfected, until it finally broke away from traditional bronze craft to develop on its own.

During the Six Dynasties Period, as external trade expanded and the influence of Buddhist art spread through China, gold and silver articles used in Buddhism emerged, often influenced by the northern nomads or the Persian Sassanid Empire.

Gold and silver articles in the Tang Dynasty showed great variety, including tableware, drinking bowls, vessels, containers for medicine, miscellaneous articles for household use, ornaments and articles for religious use. Moreover, the process in making them was increasingly meticulous and complex. Hammering, casting, welding, cutting, polishing, riveting, plating, carving and piercing were extensively used. In the Song Dynasty works of gold and silver combined with wood, lacquer and other materials came into being, and the art of painting was introduced for adornment, using solid carving decoration and raised floral-pattern technique. In the Yuan Dynasty, new varieties of artworks were developed including vases, cases, *zun* (a kind of wine vessel in ancient times), *lian*

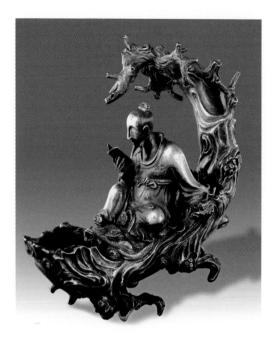

Yuan-Dynasty silver artwork, carved from a dragon-shaped stump. The artifact shows a Taoist priest sitting against a stump reading a book held in hand.

(toilet case used by women), and shelves. In the Ming and Qing dynasties, gold and silver articles were refined in shape and the workmanship aimed to be most pleasing to the eye. In the Qing Dynasty, the compound process became more developed, by which gold, silver combined with enamel, pearl, jade and gems set one another off to glittering effect.

Glassware

Glass containing lead and barium emerged as early as the Western Zhou Dynasty. Lead-barium glass requires a relatively low melting temperature. It looks sparkling and crystal clear, but is thin and brittle, and cannot withstand sharp drops or rises in temperature. It is therefore unfit for making utensils and was most often used to make ornaments, ritual objects or funerary objects.

By the beginning of the Warring States Period, dragonfly-eye and jade-imitation glass were invented. Dragonfly-eye glass is prepared by adhering multicolor rings on top of glass beads, which look like dragonfly-eyes, hence the name. In the Spring and Autumn and Warring States Period, glass techniques matured and technical exchanges with foreign countries began. The technical process of making glass includes casting, twining, and inlaying skills. Glass objects such as *bi* (traditionally a round piece of jade with a hole in its center used for ceremonial purposes in ancient China), rings and swords were prepared by pouring melted glass into moulds.

In the Han Dynasty, glass manufacturing became poly-centered, mainly in three regions: in the Central Plains region, the Zhou Dynasty process was followed, producing chiefly lead-barium glass; in the Hexi Corridor region (in Northwestern

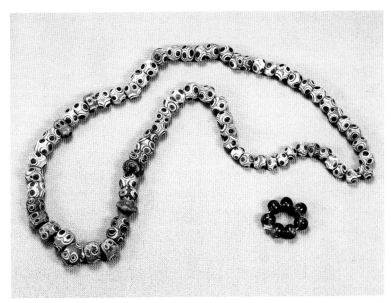

Dragonfly-eye glass bead necklace of the Warring States Period (Hubei Museum). Each bead is 2.5 cm in diameter.

Gansu, so called because it lies to the west of the Yellow River) lead-barium glass was also produced with the traditional formula, adding sodium and calcium; in the Lingnan Region (the area covering Guangdong and Guangxi), centered on Guangzhou, potassium-silicon glass was produced. In the Wei, Jin, Northern and Southern dynasties, regional separatist regimes preferred importing foreign glass, in particular in the Northern Dynasties Period, when the rulers not only imported glass, but also introduced western glass technology to China. In the Sui Dynasty, a eunuch named He Chou, drawing on the experience of green porcelain manufacturing, successfully produced his own glass. Glass in the Tang Dynasty was mainly high-lead glass without barium, but sometimes containing sodium.

Qing-dynasty blue transparent glass bottle (Palace Museum).

From the Ming and Qing dynasties, glass types diversified. In the Ming Dynasty, Yanshen Town (now Yidu, Shandong Province) was a hub of glass production, where the site of glass furnace ruins that had long fallen into oblivion has now been excavated. The Qing Dynasty was at the zenith of ancient glass manufacturing. Glass production at that time was concentrated in Guangzhou in the south and Yanshen Town in the north. The imperial glass factory was known for merging together the glass processes of north and south with European techniques. Imperial glass was plain and unusually exquisite, representing the achievements attained in glass making in the Qing Dynasty.

Sui-dynasty covered pot made of green glass.

Enamelware

Manufacturing enamelware is a complex process combining enamel and metal processing. It is prepared by first grinding quartz, silicon, feldspar, borax, and some metal minerals into powder and then melting them, and then applying them onto metal utensils to form a surface after baking. Sometimes polishing or gold-plating is needed. Enamelware, which has the sturdiness of metal and the smoothness and corrosion-resistance of glass, is practical and beautiful. To date, the earliest enamel object known to have been made in China is the Tang-dynasty gold-inlaid silver-base enamel mirror now kept in the Shosoin Repository in Nara, Japan. But no other enamelware has been discovered that was made in the following three or four centuries. In the late years of the Yuan Dynasty, Chinese enamelware became less influenced by Arabian culture and more and more nationalized.

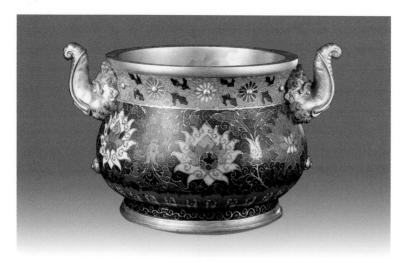

Yuan-dynasty elephant-ear heater, made of copper and decorated with enamel and gold (Palace Museum).

The different processes of enamelware include gold inlay, coating, and painting; bases include gold, copper, porcelain, glass, and purple clay. Among the latter, copper-base enamel is the most popular, because the price of copper is relatively low, and enamel is easier to adhere to a copper surface. The distinguished traditional Chinese handicraft of *Jingtailan* (cloisonné enamel), its scientific name being "copper background wire-inlay enamel," got its name from being made in large quantities in Beijing during the Jingtai Reign of the Ming Dynasty, and the enamel used was mostly of a blue color. The procedure of *Jingtailan* includes chiefly base-making, wire-inlaying, firing and soldering, blue enamel coating, enamel-baking, polishing, and gold-plating. Coating is done by using a small iron spade or glass tube to apply glazes of different colors first on the background, then on the designs and then a final coating of blue glaze and a shiny white substance. The glazing and baking procedure is repeated, one glazing followed by one baking, as often three coatings are needed for quality cloisonné.

Promoted and supported by the Qing government, enamel handicraft grew fast in the Qing Dynasty based on the achievements attained during the Yuan and Ming dynasties. In the reign of Emperor Kangxi, an enamel factory was set up at court, at first making wire-inlay enamel and base-engraving enamel, and then successfully attempting painted enamel. Painted enamel, often used on small objects, is heavy and thick in color, similar to the mixed glaze of earlier times. Porcelain-base enamel, also called enameled color porcelain, involves the application of enamel paint onto a porcelain base. It is a perfect combination of porcelain and painted enamel craft. In the reign of Emperor Qianlong, painted enamel craft was booming. Aside

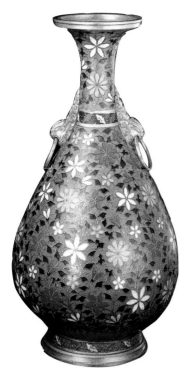

from the court, Guangzhou was the major center of painted enamel making. Painted enamel works made at the court featured a neat design, meticulous painting, and an elevated style, using mostly a bright yellow color associated with royalty. Painted enamel works made in Guangzhou feature bold and unstrained lines, often decorated with a European-style design of rolled-up leaves, using colorful and sparkling glaze material imported from the West. At that time, snuff bottles of diversified types and meticulously produced were made of enamel, jade, agate, crystal, and porcelain, decorated with calligraphy and drawings. Even Western subject matters, such as European women and babies and Western-styled pavilions and towers, were adopted for designs, which was rarely seen in previous dynasties.

Ming-Dynasty enamel bottle (Palace Museum).

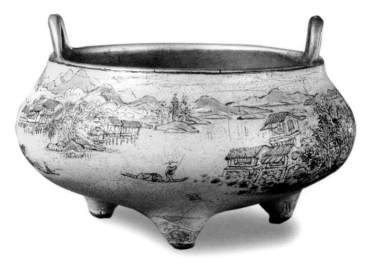

Qing-Dynasty enamel landscape incense burner (Palace Museum).

Bamboo, Wood and Ivory Carving

Bamboo Carving

China was the first country in the world to start using bamboo articles. Often, ornamental patterns or characters are carved on bamboo items, or ornaments are made by carving bamboo roots. The earliest extant carved bamboo is the painted lacquer bamboo ladle unearthed from the Western Han Tombs No.1 in Mawangdui, Changsha. Decorated with dragon and braid motifs using bas-relief and fretwork techniques, it is a highly finished rarity.

From the mid-Ming Dynasty, bamboo carving developed into a special art. At the very beginning, there were only a few well-educated artisans in the trade. As bamboo was easily available, however, more and more people started to join in this craft, some by handing down from father to son, some by passing on from master to apprentice, some by learning from others privately, until bamboo carving became a special trade with a great quantity of works preserved for posterity. Bamboo joint carving

Ming-dynasty brush pot (Nanjing Museum).

Qing-dynasty brush pot with a relief showing a monk carrying a staff (Palace Museum).

is the most representative variety in bamboo carving: bamboo joints are shaped into practical items like brush pots, incense tubes, and tea caddies; then its surface is pierced to make a relief decoration.

The techniques of bamboo carving include keeping the green-covering, pasting yellow chips onto the bamboo, round carving and inlaying.

In the craft of "keeping green covering," motifs are carved by removing part of the surface to reveal the pale yellow underlayer, the "bamboo muscle," which is used as background. When a bamboo is dried, its outer layer gradually turns from green to light yellow, and then stays that way. But the bamboo muscle will change from light yellow first to deep yellow, then to reddish purple with color and luster growing deeper and deeper until it resembles amber. When the bamboo muscle is polished by hand, it will become smooth and mild. As time goes by, the outer layer and the bamboo muscle differ distinctly in luster and color, and the designs become more and more distinct.

The yellow chip (bamboo muscle) refers to the light yellow inner layer of the bamboo. It is glossy and smooth, like ivory. In the craft of pasting yellow chips, large bamboos from the south are used as material. Fresh yellow chips are boiled, dried in the air, flattened by pressing,

and then pasted onto the surface of objects made of various materials. Often wooden articles are used, among which wood that is fine in texture and similar to bamboo yellow chips in color and luster, is the best choice. Sometimes two or three layers of yellow chips are pasted on as required by the design so as to make several patterns closely linked up as if wrought through the invisible hand of nature. The technique of pasting yellow chips prevailed in the Qing Dynasty in many places across the country.

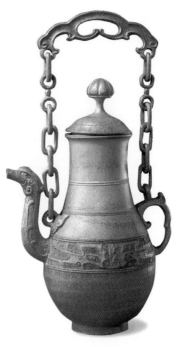

Qing-dynasty carved bamboo loop-handle pot (Palace Museum).

In the craft of round carving, bamboo roots are often used. The design is based on the natural shape of the roots on which carving or piercing is applied with a light touch to make ingenious ornaments that appear unsophisticated. At that time, the Feng family in Jiading was the most skilled in round carving, having inherited the techniques from the Zhu family. The works they made, using bamboo roots as material, imitating nature in design, were known for their originality in shape and glowing with radiance and vitality.

In order to add a sense of gradation in wood and bamboo carving, the inlay process is used: designs are formed by combining materials of different textures and colors, or a "treasure inlaid artwork" is created with jade, stone, bamboo, wood, and bone set onto a single piece of work.

Wood Carving

Wood carving in China constitutes three major categories: architectural carving, furniture carving and decorative carving.

Wood carving as handiworks for display or as objects to caress started in the Song Dynasty when the practice gradually rose among men of letters and refined scholars. This prevailing custom reached its climax in the Ming and Qing dynasties. Decorative art for the home is a traditional category in wood carving, with objects made to be placed on cabinets, windowsills, tables, or shelves. Wood carving can also be used to decorate all sorts of furniture and other artworks such as jade-ware, cloisonné and chinaware.

Wood carving can be found all over the region on both sides of the Yangtze River, where the best known schools included the Dongyang woodcarving of Zhejiang Province, the golden-lacquer wood carving of Guangdong Province, longan wood carving in Fujian Province and Huizhou wood carving in Anhui Province.

Dongyang County of Zhejiang Province has always been celebrated as the "home of carving." Dongyang wood carving started in the Tang Dynasty, developed in the Song Dynasty and became popular in the Ming and Qing dynasties. Dongyang carvings preserve the original textures and colors of the wood

Ming-dynasty eaglewood mandarin duck hand warmer, 5 cm high, 6.5 cm long, 6.5 cm wide.

which, when meticulously polished, make the finished works appear smooth and lustrous. Relief carving is the essence of Dongyang woodcarving; the depth of the patterns ranges between two and five millimeters. The centerpiece is distinguished by the greater force of the cutting. The unique designs of Dongyang woodcarving have patterns carved over the entire surface of the object to create a three-dimensional display while the background is fully covered.

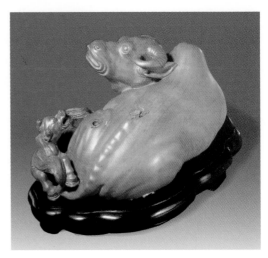

Cow Suckling its Calf, Chinese littleleaf box wood carving, 8 cm high, 12.3 cm long, (Palace Museum).

Gold lacquer woodcarving, so named because of the gold coating on the surface, is a specialty of the Chaozhou region in Guangdong Province. It began in the Tang Dynasty and even earlier as a decorative art used in ancient Chinese architecture. Later on, it was influenced by local art and became a school of woodcarving featuring local flavor. Chaozhou's special lacquer not only enables the gold foil to adhere to the surface of the wood, but also makes it moisture-proof and rot-proof. The Qing Dynasty saw the heyday of its development, when the fretwork developed from single-layer to multi-layer piercing, producing an artistic effect of a strong depth and perspective.

Fujian longan (Euphoria longan, an evergreen tree) carving developed from furniture decoration and Buddha carving and matured around the end of Ming Dynasty and the beginning of Qing Dynasty. Longan is slightly brittle in texture, fine grained, reddish brown in color, and mainly found in the southern area of Fujian Province. The roots of mature longan often

grow into spectacular or grotesque shapes, making it an ideal wood for engraving. Root carving therefore became the unique variety of Fuzhou wood carving. Local artisans made the best use of the natural shape of the twisted roots with their rough nodes, by chopping them with an axe or cutting them with a chisel, and were skilled at carving the wood into all kinds of vivid and artistically exaggerated figures, birds and beasts. When smoothed and polished, Fuzhou wood carving reveals a natural brass yellow or orange color that will never fade.

Wood used in Huizhou woodcarving includes soft wood species such as pine, China fir, camphor tree, nanmu, and gingko. What makes Huizhou wood carving special is not the quality of the wood, but the content of the subject matter, the skill at carving, and the perfection of composition and lines, which has exerted a great influence on the surrounding areas. In the Ming and Qing dynasties, Huizhou wood carving was focused on architecture and furniture decoration, well-known for its giant carved paintings whose themes are mostly traditional scenes of agricultural life, fishing, woodcutting, plowing, studying, or scenes from fairy tales, legends, historical stories and classic novels.

Ivory Carving

Early in the Neolithic Age, the ancient Chinese already started to use articles made of bones, fangs and horns from animals alongside stoneware, wooden articles and pottery ware. Materials for carving taken from animals are mostly ivory. The animal-mask patterned ivory cup inlaid with pine-and-stone design found in the Fuhao Tomb in the Yin Ruins, Henan in 1976 can be considered representative of Shang Dynasty ivory carving.

Ivory carving made rapid progress in the Song Dynasty, exemplified by the multi-cased ivory ball, called "Superlative

Workmanship," using a fretwork process perfected by the royal handicraft workshop. On the surface of the ball, relief patterns in exquisite and complicated designs are engraved; inside the ball are several hollow balls of different sizes, one on top of the other.

In the Ming and Qing dynasties, as economic and cultural exchanges with South Asia and Africa increased and ivory was introduced to China, the art of ivory carving entered a period of full bloom. In the Ming Dynasty, ivory carving was mainly done in Beijing, Yangzhou and Guangzhou, and was widely pursued by both government and folk artisans, men of letters and refined

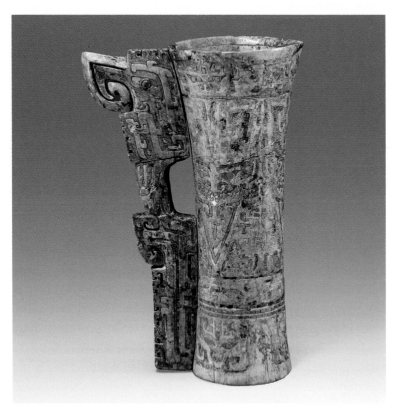

Shang-Dynasty ivory carving: *kuipan* (dragon-like monopod animal) cup discovered in the Fuhao tomb at Yin Ruins, Anyang, Henan (National Museum of China).

Ming-Dynasty ivory carving: human figure, 20 cm high (Shanghai Museum).

Qing-Dynasty ivory filament plaited round fan (Palace Museum). It features the cleave-plaiting craft unique to Guangdong ivory carving.

scholars. Ivory artworks and other small-sized carved articles using bamboo, wood, gold, and stone became highly desirable curios and ornaments. At that time, ivory and rhinoceros horn presented no special difficulties compared to bamboo, wood, gold or stone carving as far as carving skills were concerned, and many craftsmen routinely used different materials, becoming all-rounders at their trade.

In addition to the common techniques such as single-line intaglio carving, round carving, relief carving, micro-carving, and so on, there are three skills unique to Chinese ivory carving: fretwork, cleaving-plaiting, and inlaying-dyeing.

The most typical item of fretwork is the intricate hollowed out ivory ball. Some have dozens of layers, cased one on top of another, each able to revolve independently. The process of cleaving-plaiting is to use ivory's properties of marvelous tenacity and fine grain, and cleave the ivory into very thin pieces which are then plaited into products such as mattresses, round fans, flower baskets, or lampshades. As ivory can only be cleaved into fine pieces in an environment with a temperate and moist climate, this kind of craft naturally became concentrated in the southern regions. Finally, the craft of inlaying-dyeing has two different forms: one, to inlay other gorgeously colored materials onto the surface of ivory items; the other, to

Ivory carving of twelve Chinese signs of the zodiac.

inlay ivory pieces together with a bright, shiny material such as precious stone, according to designed patterns. Dyeing improves the monotonous color and the natural blemishes on ivory and horn. Inlay-dyeing enhanced the decorative effect of carved ivory items, making them more brilliant, graceful and colorful.

Decoration

Jade

Jade has long been cherished by the Chinese as a symbol of many virtues: its hardness suggests firmness and loyalty and its luster projects purity and beauty. Traditional subjects for jade carving are flowers, animals, vases and human figures.

In the Neolithic Age, when people gradually recognized colored stone similar to jade in choosing stone, they used it to make implements, ornaments and sacrificial offerings. The colored stone items can be considered the embryonic form of jade artworks, and can be traced back to the Hemudu Culture in China. By

Jade pendant of the Hemudu Culture, one of the earliest discovered so far.

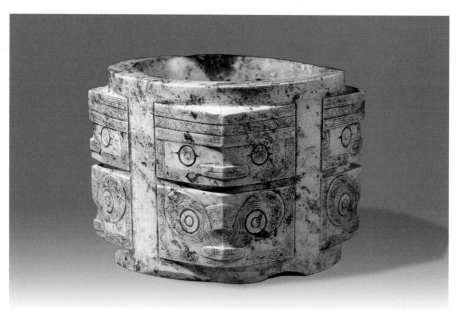

Animal-mask patterned *cong* (long hollow piece of jade) of the Liangzhu Culture, 8.8 cm high, about 6,5 kg in weight.

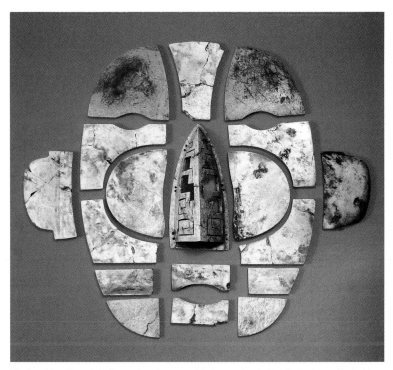

Western Han-Dynasty jade mask, a funerary object carved out of a whole piece of jade into a dozen or so pieces for each correspondent part of the face

the middle and late years of the Neolithic Age, jade-carving had been detached from stone-ware making to become an independent handicraft.

China remains a major jade producer in the world today. According to *Shan Hai Jing* (*Book on Mountains and Seas*), an ancient book about geography, there are more than two hundred places where jade is found, which means that the supply of jade is almost inexhaustible in China. Famous jade is found in Hetian in Xinjiang Province, Jiuquan in Gansu, Lantian in Shaanxi, Dushan and Mixian in Henan, and Xiuyan in Liaoning.

Generally, the process of jade carving includes close observation of the stone, designing, opening, piercing, cutting, and polishing. Tang Rongzuo, a collector in the late Qing

Dynasty, wrote a book entitled *Of Jade* in which the working procedure, methods and implements in carving jade are illustrated with twelve color drawings. A jade artwork is not made by carving, but by grinding the stone with water using minerals (such as emery, silicon, and garnet) that are harder than jade: this process is called jade rolling or jade grinding. While the skills involved in grinding jade are complex, the tools used are simple and crude. The primitive implement used is simply a revolving round disk called *tuo* (emery wheel), which is used to move emery stone which rubs, smoothes and polishes the jade. During the Neolithic Age and

Jade carving: an illustration in *Tiangong Kaiwu* (*Exploitation of the Works of Nature*).

the Bronze Age, when ironware had not yet been invented, the tools used were largely made from wood, bamboo, and animal bone compounded with sandstone. Until modern times, Chinese people used traditional tools in the manufacture of jade artworks, such as a wire saw and a round disc made of steel and wrought iron.

Jade carving was highly developed in the Han and Tang dynasties. Funerary jade was the most typical of the Han jade articles. It was made in the belief that jade would keep the body from decaying. Funerary jade articles include jade apparel and the "nine orifice stopper." Jade apparel was inlaid with gold, silver or copper and prepared while taking into account the identity and official title of the dead (see jade mask illustration). The "nine orifice stopper" was used to cover the nine orifices of the ears, eyes, mouth, nostrils, anus and genitals in the hope that

the body would not decay as the vital energy would be preserved by the orifice stoppers. As regards jade articles for ornament, jade galloping steeds, jade bears, jade eagles, and jade *bi xie* (a legendary holy beast like a lion, with two wings, said to drive out evil things), were manufactured in the Han Dynasty. Tang

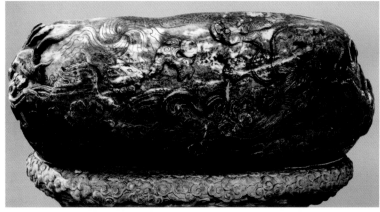

Du Shan Yu Hai (Extra large jade of Dushan), a jade carving from the Yuan Dynasty, 70 cm high and almost 5m in circumference.

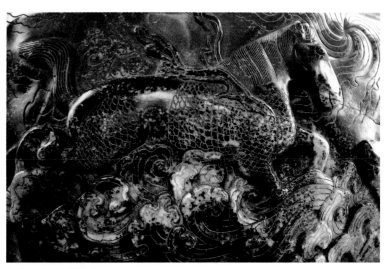

Du Shan Yu Hai (detail).

Dynasty jade artworks, influenced by painting, sculpture, and the art of the Western Region, are represented by the eight-petal pattern jade cup and animal mask agate cup, in a dignified and stately style.

Circumstances change with the passage of time, and from the Song-Liao-Jin Period onwards the function of jade objects as sacrificial vessels was weakened with the prosperity of urban economy, and instead, jade artworks closer to practical life, some as ornaments and some for daily use, dominated. In the Song Dynasty, the "qiao se" (wise use of color) process was initiated by which various extremely refined objects could be carved taking inspiration from the natural luster and color of the jade material and its texture and shape.

Yu the Great Curbing the Flood, a jade carving from the Qing Dynasty, is the world's largest piece of jade, 224 cm high, 96 cm wide, more than 5,000 kg in weight (Palace Museum).

The Yuan, Ming and Qing dynasties were the heyday of jade carving. *Du Shan Yu Hai* ("extra large jade bowl of Dushan") and *Da Yu Zhi Shui Yu Shan* ("Jade Mountain: Yu the Great Curbing Flood") were two representative pieces of the time. The artwork *Du Shan Yu Hai* was carved following the natural shape of the jade material to form a scene of auspicious animals swimming at will over the waves, reflecting the heroic spirit of the Yuan people. The work *Da*

Inscriptions on the back of *Yu the Great Curbing the Flood*.

Yu Zhi Shui Yu Shan manifests the influence of literati painting on artworks taking the Song Dynasty painting *Yu the Great Curbing the Flood* as inspiration.

Paper cutting

Paper cutting is a long-standing decorative folk art in China. The cutter first draws the design on a piece of paper and then cuts it out with scissors or a knife. In the countryside, paper cuts are often stuck on windows and doors as auspicious and joyful decorations to mark festivals and happy occasions. Often decorative patterns like babies, gourds, or lotus are used to symbolize a wish for offspring and a gift of blessings. As a type of folk art, paper cutting evinces distinctive local features: unpretentious and uninhibited as in Shaanxi; graceful and fine as in Hebei; resplendent and orderly as in Sichuan; exquisite and pleasing as in Jiangsu. Paper cuts are also used for decorating gifts or as a gift itself.

Paper cutting uses either scissors or a knife. In scissor cutting, component parts of a pattern are cut out and pasted into a whole, and then the pattern is clipped round with sharp scissors to make a fine finish. In knife cutting, the paper is folded into several layers, placed on a soft mixture of ash and animal fat, and then cut carefully with a small knife. In comparison with scissor cutting, knife cutting allows for more patterns to be cut at one time.

Blocking flower papercut from the Northern Dynasty (Xinjiang, Uygur Autonomous Region Museum), the earliest papercut discovered so far.

The three different methods of paper cutting are cut-in-relief, intaglio and mixed carving. The relief-cutting process is a development of traditional Chinese linear pattern tracing and its products are extraordinaryily exquisite with the

lines cut as fine as hair. In intaglio the images appear bolder with bright spots or white lines incised into a dark surface. The development of the mixed skill using relief cutting and incised cutting alternatively, further enriched paper-cut art. With respect to coloring, there are again three skills: multicolor cutting, dyeing cutting and golden-color cutting. In multicolor cutting, more than two polychrome sheets are put together to form a pattern before cutting. In dyeing cutting, dyeing liquid is dripped onto finished paper-cuts. The permeability of water allows the different colors to seep into each other without being confused, thus producing a bright and colorful effect. In golden color cutting, patterns are cut using gold paper and then set off with all sorts of colored paper so as to appear most resplendent and magnificent, suitable for festival decorations.

The art of paper cutting in China came into being during the Han and Wei period before iron tools and paper were even invented. The thin gold and silver sheets used as ornaments in the Warring States Period were similar to paper in shape. In the Western Han Dynasty, people started to make paper using hemp fibers. Legend has it that Emperor Wu of the Han Dynasty (156–87 BC), missing his favorite concubine Lady Li, gave an order to a sorcerer to carve a figure of Lady Li in hemp paper in order to call back the spirits of the dead lady. That is perhaps the earliest mention of a paper cut. The two round pieces of flower-patterned paper cut of the Northern and Southern Dynasties found in the old city of Gaochang, Xinjiang, are the earliest

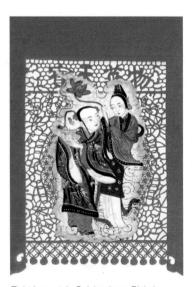

Eight Immortals Celebrating a Birthday, a Beijing painted paper cut from the Qing Dynasty, from the collection of Wang Shucun.

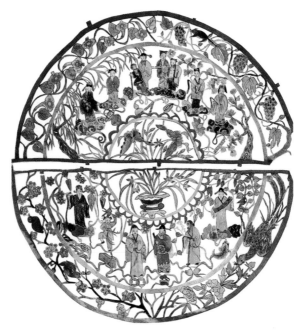

Eight Immortals, a figure paper cut from Huangxian, Shandong, created in the Qing Dynasty (Shandong Art Gallery).

known paper-cut works made in China. They were cut from folded hemp paper and used as sacrificial offerings, showing the excellent craftsmanship of the artists.

Paper making was highly developed in the Song Dynasty, which saw the invention of many varieties of paper, which led to the enrichment of paper-cut varieties, such as paper cuts to decorate windows, lanterns or teacups. From the Song Dynasty, paper cutting had also become an applied art. For instance, paper-cut designs were used for ceramics in the Jizhou kilns in Jiangxi Province. The process is to paste paper-cut works on china wares in the course of glazing before baking in the kiln. In the Song Dynasty applications of paper-cut techniques expanded further, for example in making shadow play figures out of the

hides of animals such as donkeys, oxen, horses and sheep. By that time, professional craftsmen specialized in paper cutting, some good at cutting calligraphic works of all schools; some well versed in cutting all sorts of designs. In the book entitled *Zhiyatang Zachao* (Miscellaneous Records of the Lofty Aspiration Hall) written by Zhou Mi (1232–c. 1298) of the Song Dynasty, the first artisan recorded in the history of paper cut is named as Yu Jingzhi.

In the Ming and Qing dynasties the art of paper cut reached full bloom. It was applied on folk lanterns, fans and embroidered fabrics. For example, the running horse lantern of the Ming Dynasty is a kind of decorative lantern with a revolving circle of colorful paper-cut horses and other figures, which revolves as hot air ascends from the candle burning within it. Paper-cut works are still commonly used for household decoration.

Paper-cut artisans are mainly women, as paper cutting was classed as a category of needlework, considered an essential female accomplishment. Through imitative cutting, repeated cutting, drawing-and-cutting, starting from familiar objects such as fish, insects, birds, animals, flowers, plants, pavilions, bridges or scenery, girls were taught to master the art until they were able to cut new designs spontaneously following their own inclinations.

Aihu (cloth tiger filled with the Chinese medicine moxa), a folk papercut from Shandong Penglai, traditionally pasted on doors during the Dragon Boat Festival.

Mice Stealing Oil, a Shaanxi papercut used for window decoration.

Paper cut of Chinese signs of the zodiac.

Traditional New Year Pictures

New Year pictures came out of the Spring Festival culture. In China, by the close of the year, New Year pictures are pasted in many places to represent an auspicious start to the year. New Year pictures are either printed, made of paper cut or drawn on paper. Prints are usually woodcuts. The working process includes drawing a draft, sketching an outline, woodcutting, making plates, printing, coloring and framing. Alternatively patterns are carved into the paper, or the picture is drawn on using charcoal sticks to draw drafts of lines, and then making a transfer with another sheet of paper placed on top, by applying the burning ash of a willow branch on it; by this method a few copies can be produced from each draft, which are then colored in. This technique, called "gray put," began to surface during the Chenghua Period (1465–1487) and became more influential later on, leading to the Japanese art of "ukiyoe."

Spending Winter Days: A New Year Painting from Wuqiang, Hebei made in the Qing Dynasty.

New Year Picture from the Ming Dynasty: *Door Gods Qin Shubao and Yuchi Gong*, painted with meticulous brushwork in rich colors, specially prepared for aristocrats.

New Year pictures originated from the tradition of pasting up images of "door-gods" to protect a home from misfortune. According to the book *Du Duan* by Cai Yi (132–192) of the Eastern Han Dynasty, the pictures of Shen Tu and Yu Lei, two gods guarding the gateway to the high spirits, were pasted on the doors of the ordinary people. It was said that when Emperor Taizong of the Tang Dynasty fell ill, he heard ghosts and monsters wail outside his sleeping quarters, which disturbed his sleep all through the night. Knowing this, the two senior generals, Qin Shubao and Yuchi Gong, offered to stand guard at the royal palace, one holding a sword, and the other two iron staffs. Later on, the Emperor had the pictures of these two generals drawn and pasted them on the palate gate. Since then, the custom of displaying "door gods" spread among the people. One is Qin Shubao, white faced with eyes like a phoenix,

holding two maces; the other is Yuchi Gong, black faced with round eyes, holding double iron-staffs.

With the invention of carved block printing in the Song Dynasty, the woodcut print made much improvement. New Year pictures henceforth multiplied both in function and content. At first, the subject matters were mostly talismans to obviate evil spirits, and then symbols of auspiciousness, longevity, and blessings were added to express good wishes for the coming year. At the same time, folk tales and stories were included, depicting the real life of ordinary farmers. The earliest extant New Year picture is the "Picture of Four Peerless Beauties" of the Southern Song Dynasty, the four beauties referring to Wang Zhaojun, Ban Ji, Lü Zhu and Zhao Feiyan, who were household names in China.

Ten Thousand Tael of Gold: auspicious painting from Suzhou, Jiangsu, made in the Qing Dynasty.

Other themes often used include jubilation, exorcising evil, customs, scenery, flowers with birds, or court ladies on a spring outing. In the last years of the Ming Dynasty, the New Year picture became a genre of painting in its own right. Since the prosperous period of Qianlong and Jiaqing, three major centers of manufacturing New Year pictures gradually came into being: Tianjin Yangliuqing, Shandong Weifang, Yangjiabu and Jiangsu Suzhou Taohuawu.

Yangliuqing New Year pictures started from the last years of the Ming Dynasty and prospered between the early eighteenth and the early twentieth centuries. Yangliuqing New Year pictures depict a wide variety of themes of which the most typical include "Busy Farming," "Lantern Festival Celebration," "Autumn River Night Crossing," "Visiting Old Acquaintance,"

and "Good Luck for the New Year with Happy Family Reunion." The basic technique of making Yangliuqing pictures is similar to other woodcuts, including drafting, dividing plates, carving plates, printing, painting, and framing. However, the later stage work manifests distinctive local features in that stresses are laid on hand painting, and engraving skills are ingeniously merged with brushwork in painting, making the two arts complement each other.

Yangjiabu woodcut New Year pictures, starting from the last years of the Ming Dynasty and flourishing in the Qing Dynasy, have a history of over four hundred years, with a heyday in the Qianlong reign. At that time, Yangjiabu Village was known as having "a hundred picture shops, a thousand picture types and ten-thousand printing plates," with millions of pictures sold annually. Yangjiabu pictures feature lively stories, exquisite ornamentation and have lasting appeal.

Taohuawu woodcut New Year pictures are the chief folk woodcut pictures in the region south of the Yangtze. In the Hongzhi Period (1488–1505) of the Ming Dynasty, the artist

Fish Changed into Dragon, a New Year picture from Yangliuqing, Tianjin, painted in the Qing Dynasty.

Men Busy on Ten Fete Days; *Women Busy on Ten Fete Days*: folk blockwood New Year paintings from Shandong Weifang, Qing Dynasty.

Tang Yin (1470–1523) built a cottage named Taohua Hut there at Taohuawu near Shangzhou, hence the name Taohuawu. The making of Taohuawu New Year pictures originated from the engraving and printing craft of the Song Dynasty, and were derived from embroidered portraits. It developed into a genre of folk arts in the Ming Dynasty and flourished in the reign of Yongzheng and Qianlong. The pictures feature symmetric composition, resplendent coloring, and diversified themes, including legends, dramas, social etiquette, current affairs, news, beauties, babies, kitchen gods, holy horses and much more.

Plays and playing

Toys

Toys have been part of human life since the early Neolithic Age. Folk toys in China have existed for a long time, spread over a wide area, with diversified types and styles made from numerous raw materials. In terms of functions they fall into seasonal toys, educational toys, acoustic toys, keep-fit toys, toys for viewing and enjoying and practical toys. Materials used included clay, fabric, bamboo, wood and paper.

Seasonal toys are closely connected with folk customs, subject to a certain season or festival time. Firecrackers and fireworks are used at the Spring Festival; "running horse" lanterns and auspicious image lanterns for the Lantern Festival; lotus lanterns for the Spirit Festival; sachets, cloth tigers, moxa-filled figures, and the five-filament whistle for the Dragon-boat Festival; the old rabbit for the Mid-Autumn Festival; kites for the Festival of "Pure Brightness"; and many more. Educational toys can arouse people's curiosity and encourage creativity, such as the tangram puzzle, informative map, playing cards, small

Han-Dynasty red pottery acrobat figurines.

Painted cloth tiger from the Qing Dynasty.

game puzzle, nine-circle puzzle, Lubanga lock, and the nine-square puzzle. Acoustic instruments such as earthen whistles, china whistles, diabolos, wheels (a wooden shaft at either end of a disk), rattle-drums, tiny gongs and drums, and glass trumpets are suitable for small children. Toys for viewing and enjoying are mainly for decoration and include wood carvings, stone carvings, clay figures, wax figures, dough figurines and so on. Keep-fit toys are mostly for outdoor activities such as *Cuju* (an ancient game similar to football), rope skipping, shuttlecock, swinging, and "pot vote" (a throwing game). Practical toys can also be used as dress, bedding or food, such as tiger-head shoes, tiger-head caps, sugar figures and "flower face" (a kind of bun). Toys made of clay are the oldest, most widespread, most numerous and most traditional toys. They can be traced back to the Neolithic Age some five or six thousand years ago. By the Eastern Han dynasty, clay toys and earthen toys had already become popular. The earliest toys still in existence are Tang Dynasty clay figurines. In 1973, a large quantity of rare cultural relics of the Tang Dynasty was excavated from the ancient tombs in Astana, Xinjiang, among which a group

of four painted laboring clay figurines from Tomb No. 201, vivid and natural in shape, give a truthful representation of the processes of food preparation at that time. From the Song Dynasty onwards, clay toys turned into commodities with professional artisans specializing in making toys sold through itinerant peddlers and street stalls. Clay toys spread to almost every region where they became closely connected with local conditions and customs.

Wuxi Huishan clay figurines originated in the Ming Dynasty and are typical of clay toys in China. The clay, taken from the foot of Huishan Hill, has a unique delicate texture. It is said that the area where Huishan clay is obtained covers only a little over one hectare of land. Production of the figurines combines molding with painting, including filtering and hammering the soil, drafting, molding, shaping, smoothing, painting, facial making up and oiling. In most cases clay toys are made with a mold. First, molds are made according to the original shape, and then clay bodies are impressed onto the mold. The bodies are hollow so as to reduce weight and save material. The basic color is often white, with the "halo retreat" technique used to make the color vary from deep to shallow.

At the early stage Huishan clay figurines were primarily toys for kids, produced with molds, simply painted, represented by Da Afu. A folk tale widely circulated about Afu says that many years ago in the Huishan region a wild beast roamed, endangering children. A child named Sha fought courageously with the fierce beast and eliminated the evil creature. In memory

Qing-dynasty Wuxi clay figurine Da Afu: an exquisitely painted hollow thin-bodied work.

Toy stall.

Tangram: an educational toy.

Patterns formed by reassembling the tangram.

of him people molded his likeness into a figure using clay from Huishan. Though the images of Afu differ in the hands of different craftspeople through the ages, the basic shape remains a plump full-size doll in a jacket bearing a five-character *fu* (blessing), embracing a lion, with a serene smiling face. The message Da Afu brings is always *fu*, meaning blessing.

The rattle-drum, the earliest ancient Chinese toy, which appeared in the Warring States Period, is an example of acoustic toys. The drum has a handle, and two small balls attached at either side by a string, which strike the drum when the handle is turned to and fro. The drum is made from wood or bamboo, covered with sheep hide, ox hide or snake skin: the drum with a wooden frame and sheep hide membrane is the most typical. It was first used for ceremonial purposes, and later on became an acoustic instrument in common use. As it can produce a light and merry sound to attract people's attention, it was used by vendors to solicit customers. It is also an ideal toy for infants, helping to hone their grasping and holding strength as well as test their hearing and sense of touch. Over two thousand years, the shape of the rattle-drum as a combination of toy and musical instrument has seldom changed and it can be seen in pictures from past dynasties in nearly the same shape as today.

Educational toys in China can be classified into board-type, chess-type, ring-type, card-type and block-moving-type. Board-type toys were mostly created by ancient scholars; they include primarily tangrams, informative maps, 16-*qiao* plate, 21-*qiao* plate, and so on. A tangram is a jigsaw puzzle consisting of seven thin plates placed in a square or rectangle, from which different patterns can be formed. The tangram was derived from the Song Dynasty "swallow pattern" invented by Huang Bosi, who used six rectangular tables and a small side table to form a swallow-shaped pattern. The pattern gradually spread across the north and south of China, and even to the West.

Kites

The kite is one of the most typical Chinese folk toys, combining aesthetic appreciation with entertainment, competition, and exercise, and is closely connected with folk customs, festivals, science and technology, and history. Flying kites is closely associated with the tradition of "Pure Brightness Day." In the past, people used to write their own names on the kite when they were in distress or fell ill. As the kite was flying high above, they cut the string and let the kite fly away with the wind. In so doing they believed that their bad luck had disappeared with the kite.

The name of the kite varied at different times. Sources from the pre-Qin period record that the thinker Mo-tzu and the master craftsman Gongshu Ban had both made something called a "wooden hawk." Later it was said that the distinguished general Han Xin (?–196 BC) made "paper hawks" in the first years of the Han Dynasty. According to more reliable sources, the kite originated in the Northern and Southern Dynasties. It was named "paper crow" or "paper owl" at that time. The kite was not used as a toy but in military affairs, correspondence, measurement

Flower-basket kite made from *juan*-silk and bamboo in Weifang, Shandong.

and publicity. It was after the Five Dynasties that the kite became popular and turned into a means of entertainment. During the mid-Tang Dynasty, paper started to be more widely used in everyday life and gradually replaced other more expensive materials in kite-making, thanks to its low cost and easy working process.

By the Song Dynasty, kite-flying was popularized and kite-making became an occupation. Gradually the custom of flying kites at the Pure Brightness Festival was established. Scenes of kite-flying can be seen in both the famous painting *Pure Brightness Day on the River* by Zhang Zeduan, eminent artist of the Northern Song Dynasty, and the picture *One Hundred Sub-Graphs* by Su Hanchen.

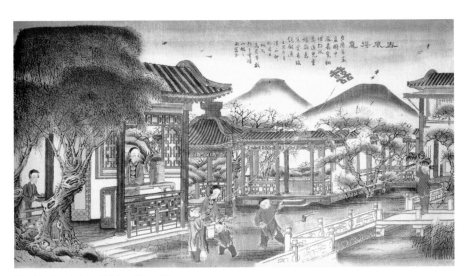

New Year's painting: *Children Flying Kites*.

Kite-flying had its heyday in the dynasties of Ming and Qing. Kids competing in flying kites became a familiar spring-time scene. Even high officials and noble lords enjoyed flying kites. In the Palace Museum in Beijing there are still three large kites that were flown by Puyi, last Emperor of the Qing Dynasty. Cao Xueqin (1715–1763), the literary giant who wrote the masterpiece *The Dream of Red Mansions*, also wrote a book entitled *Records of Crafts in Making Kites in the North and South*, which contains primarily rhymes about making kites and colored patterns of all types of kites.

Making a kite usually has four steps: making the framework, pasting paper, painting and flying. The materials used are usually bamboo, paper, or silk fabrics. The shape of the kite was fantastical at first, but later on a more realist style was developed. The structure of the kite is required to conform not only to the principle of

Enjoying Paper-Hawk Flying, an illustration in the late-Qing picture album *Painting Treasure of Wu Youru*.

Cao Xueqin and *Nan Yao Bei Yuan Kao Gong Zhi* (Records of Crafts in Making Kites in the North and South)

Cao Xueqin is best known as the author of the eighteenth-century novel *The Dream of the Red Chamber* (also known as *The Story of the Stone*), in which he displays deep knowledge of almost all branches of learning including epigraphy, painting, calligraphy, kite-making, knitting, medicine, architecture, cuisine, arts and crafts, printing and dyeing, carving and ornamentation. In his *Nan Yao Bei Yuan Kao Gong Zhi*, Cao painted a collection of kite patterns in which traditional kite patterns as well as those he designed himself are included. He also put into rhyme the process of making kites so that kite-making methods were handed down to the present time. Even after the founding of the People's Republic of China, the patterns used by masters of kite-making in Beijing are mostly taken from Cao's Records, and therefore called Cao-styled kites.

In the preface Cao explains that a poverty-stricken friend of his named Yu Jinglian came to borrow money from him one day. As it happened to be near the end of the year, Yu mentioned unintentionally that in the capital, the price of a kite bought by children from wealthy families cost so much that the money was sufficient to support a family for several months. Keen on making kites himself, Cao made a few kites on the spot and handed them to Yu Jinglian, who took them to the market and sold them at a good price. On New Year's eve, Yu came back to Cao, riding a donkey carrying wine and meat as a gift to express his gratitude. Inspired by this, Cao decided to write a book in the hope that poor people could make use of it to help make a living making kites.

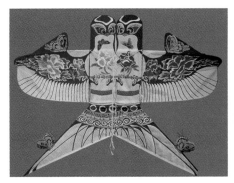

Beijing wing-to-wing swallow kite made of bamboo and silk.

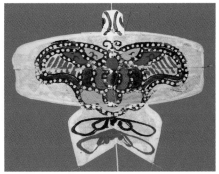

Butterfly kite made of paper and bamboo in Chengdu, Sichuan.

balance, but the principle of aerodynamics so that the kite can fly high and accomplish all sorts of elegant movements. For instance, the centipede-shaped kite is required to hold its head high; the double-butterfly rolls up and down, to the left and to the right; eagles soar and circle, big-board hawks hold firm in the sky. The New Year Picture workshops at that time used woodblocks to print colored paper specifically for kite-making, whereas artisans decorated kites with various techniques such as pasting paper, making relief from paper, paper-cut, and outlining designs in gold.

As kite-flying was an entertainment popular with all classes of society, a wide range of varieties developed: in terms of function, toy kites, ornamental kites, stunt kites, practical kites; in terms of structure, hard-wing kites, soft-wing kites, bat-shaped kites, straight-stringed kites, barrel-shaped kites, kites carrying poles, soft kites; in terms of shapes and themes, bird-shaped kites, insect-shaped kites, aquatic-shaped kites, human-figure kites, character-shaped kites, object-shaped kites, geometric-figure kites, and more. In the northern and southern regions of the Yangtze River there are kite-making centers of which the most distinguished are Beijing, Tianjin, Shandong in Weifang, Jiangsu in Yangzhou, and Sichuan in Chengdu.

Eight Trigrams kite: a type of bat-shaped kite.

The hard-wing kite is a common type, in which the two wings are made of bamboo strips connected to the trunk; these kites are non-foldable. The Beijing sand-swallow kite is the most typical of hard-wing kites. Its wings are bound with two bamboo strips, one above and the other underneath. The head and the abdomen are formed by bending a long bamboo strip into a U-shape; the tail is made of two bamboo strips crossing each other. These parts are bound together to form a framework of which each part has a fixed proportion in measurement. A hard-wing kite is easy to make, solid and durable, and is therefore favored by many people.

The bat-shaped kite looks like a flat board in the shape of a mask, a tripod, or a cicada, for example. The most characteristic is the traditional Eight Trigrams kite, which has to rely on strong wind force to fly up in the sky. The bat-shaped kites can be designed to represent all sorts of objects, characters and geometric figures.

The tile kite, commonly called "seat curtain," needs only three bamboo strips to make a framework. Two are placed crosswise

on a square piece of paper and the third is made in the shape of a bow and placed across the top. At the tail of the frame, three paper tapes are attached. The tile kite is the most commonly self-made kite.

From the Tang and Song dynasties onwards, Chinese kites started to spread to the outer world, first to Korea, Japan, and Malaysia and then to America and Europe, where, influenced by the industrial revolution in Europe, Chinese kites developed aerodynamic technologies similar to later aircraft.

Puppets

Puppets made their appearance for the first time in the Spring and Autumn Period. In 1979, a puppet was unearthed from a Han Dynasty tomb in Laixi, Shandong Province. The puppet, 193 centimeters in height and composed of thirteen articulated parts, can be made to sit, stand or kneel. The discovery indicates that the function of puppets at that time had shifted from funerary objects to entertainment, which foretold the birth of the puppet show.

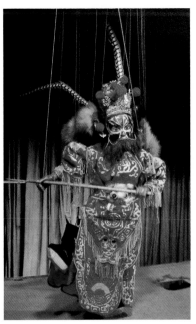

Performance of a marionette show at Heyang, Shaanxi.

In the classic book *Tong dian* (*Laws and Rules Recorded*), Du You of the Tang Dynasty writes: "In the last years of the Han Dynasty, puppets started to perform for entertainment on grand occasions. In earlier times, they were used only at funerals." By the Sui Dynasty, the embryonic form of the puppet show had taken shape. Even scenes from traditional opera could be performed with puppets. From the Tang Dynasty, the art of puppetry advanced rapidly. The murals and poems of the prosperous period

of the Tang Dynasty, stored in Cave No. 31 of the Mogao Grottos in Dunhuang, Gansu Province, indicate that different categories of puppets including glove puppets, marionettes and rod-hand puppets had already appeared.

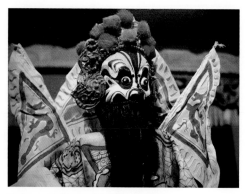

Rod puppet Jiaozan, head height 17.5 cm. Jiao is a valiant general in the traditional puppet drama, Jinxian, Hebei.

The puppet show came into its prime in the dynasties of Song and Yuan. Puppet show troupes grew in popularity in the Song Dynasty, offering performances of various subject matters. From the Yuan Dynasty, puppets could be manipulated to act vividly the gamut of human emotions—happiness, anger, grief and joy.

From the Ming down to the Qing Dynasty, diversified schools of puppet shows spread all over the country, each with local flavor of its own. Take the marionette show in Quanzhou of Fujian Province for example. Not only was the musical accompaniment highly accomplished, but the puppets were also exquisitely made and manipulated with superb skills. A single puppet figure could be controlled by as many as twenty to thirty strings. In the Qing Dynasty, the rod puppet show prevailed, and the Beijing rod puppet show was played in the royal court as a special form of Peking opera.

In traditional puppet-making craft, the head and limbs of puppet figures were made of camphorwood, which is fragrant, repels worms, and becomes especially lustrous after polishing. In general, around a dozen steps are needed in the working procedure including choosing materials, rough carving, meticulous carving, papering, polishing, coating with clay, applying powder, putting on facial makeup and coating with lacquer. The puppet show features local characteristics in that

even in the same region, the manipulating skill, design of the figures and performance may be entirely different.

Of the different varieties of puppet show, the rod puppet show is the most popular. The rod puppet show falls into three types: large-sized, medium-sized, and small-sized, according to performing style and figure designs. The small-sized puppets, also known as refined puppets, about 40 centimeters in length, are exquisite, precise in movements and adept at playing both civil and martial roles. Large-sized puppets are 1.4 meters long, five kilos heavy, and can play complex movements such as putting on clothes, lighting a fire, kowtowing, or wielding a sword. The largest puppets, similar in size to a human being often perform together with "human puppets" played by children, aiming at an effect "mixing the false with the real" and presenting the "false and true at the same time." The rod puppets are worked by the "life-rod" connecting the puppet head and two "hand rods" joining the hands of the puppet. The puppet

Puppets in the glove puppet show *A Journey to the West.* The figures measure 28 cm in height, Zhangzhou, Fujian.

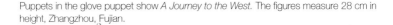

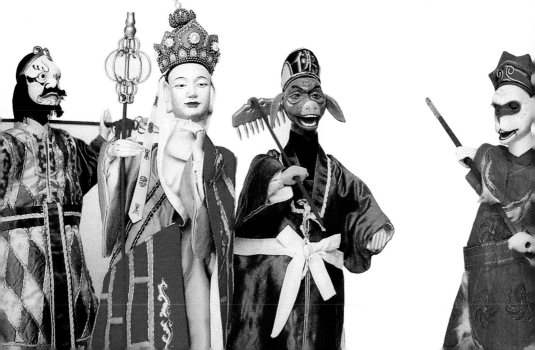

Marionettes Zhang Fei, Liu Bei, and Guan Yu, 80 cm high, Zhangzhou, Fujian.

is ingeniously designed and manipulated so that its eyes and mouth are movable.

Glove puppets, also called "palm puppets," fit onto the hand of the performer. The glove puppet show is most prevalent in Quanzhou, Fujian Province. The puppet is about 30 cm in length, consisting of a head, a trunk and clothes. The head is made of camphorwood with gears installed to control the movement of eyes and mouth. The performer's index finger is used to manipulate the puppet head, the middle finger and the thumb the two puppet hands respectively. The glove puppet show is characterized by precise and nimble movements requiring superior skills such as unfolding a fan, changing clothes, performing a sword-dance, fighting with a weapon, jumping through a window, and so on.

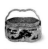

A marionette is a jointed puppet moved by strings. It is composed of the head, the trunk, limbs and manipulating strings, some sixty cm in length. Its head is carved out of camphorwood, Chinese linden or willow wood, with gears to control facial expressions. Hands are of two types: the martial type and the civil type. The martial-type hands are manipulated to wield spear and cudgels; the civil type waves fans or raises wine cups. The puppet feet can be bare, booted, or shaped like a woman's bound foot.

The iron-wire puppet show of the western Fujian and eastern Guangdong regions took shape in the last days of the Qing Dynasty and enjoyed popularity for a time. Its most distinct feature is that it maintains the manipulating skills of the shadow play. The operators work in a transparent case, using iron wire to accomplish each movement. The manipulating rod is called the iron branch. The puppet is one to one and a half meters in length and made of paulownia wood, with paper hands and wooden feet. The head is made of red clay, baked and then coated with waterproof coloring. Different types of facial make-up indicating personalities and characters are applied. The operators, sitting or standing, manipulate the puppet from behind.

Shadow Puppets

A shadow play is a popular folk performance, in which performers use leather or cardboard silhouettes to enact plays. A light is shone onto a screen, behind which performers operate the silhouettes while singing to music. Silhouettes are similar to paper-cuts, but differ in that the hands and legs are joined with string so that they are movable. The silhouette figures were cut from cardboard at first and from donkey hide or ox-hide and sheep-hide later on. Usually a piece of hide is cut, colored,

ironed and joined into a figure with nimble limbs. The tools used in making silhouette figures are knives, blades, files, drills and prods, for shaping the head, trunk, legs, hands and feet respectively.

The silhouette figures, vivid in shape and rich in color, are projected onto a screen. In a performance, the operator, while singing to the accompaniment of music, manipulates the figures as the story of the play requires. To adapt to the form of screen expression, the skill of combining abstractness and reality is applied in shadow play in which scenes are made artistic, exaggerated and dramatic. Aside from screen presentation, silhouette figures can be played with hands for personal amusement, or placed on window sills as ornaments.

The shadow play can be traced back to the Western Han Dynasty. Legend has it that in the reign of Emperor Wen (203–157 BC), a court lady who was playing with the crown prince in front of the window, had human figures cut from Chinese parasol leaves, which she managed to reflect on the gauze windows for fun. In fact, shadow play in China started from the Northern Song Dynasty and gradually prospered. According to *Dream of the Eastern Capital*, written by Meng Yuanlao in the Song Dynasty, places of entertainment increased rapidly in number, in the capital of the Northern Song Dynasty. The shadow play started as a genre of folk art alongside ballad singing, comic dialogue, and story telling with a drum accompaniment. In the capital city of Lin'an (now Hangzhou),

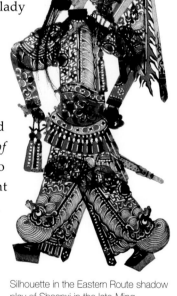

Silhouette in the Eastern Route shadow play of Shaanxi in the late-Ming Dynasty.

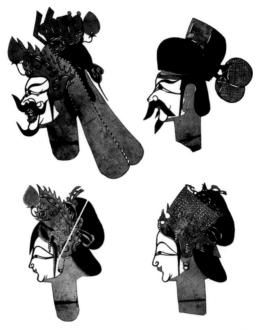

Beijing Western School shadow play in the early years of the
Qing Dynasty. The features of the different characters are
clearly distinguished with meticulous carving.

a shadow play troupe named "Painted-Leather Society" was
established. In the third year of Zhengde under the reign of
Emperor Renzong in the Ming Dynasty, a hundred-drama
festival was held in Beijing in which performances were also
given by shadow play operators. In the Qing Dynasty, the
shadow play developed further and became more popular, with
more items on the program to choose from, more varieties of
figures, and more meticulous skills in carving. During the reign
of Emperor Jiaqing (1786–1820), shadow play troupes also gave
performances in homes to celebrate New Year's Day and other
festivals. At that time, quite a few Peking opera actors joined in
the performance of shadow plays. Since the mid-Qing Dynasty,
types of facial makeup such as *sheng* (male role), *dan* (female

role), *jing* (painted-face role), *mo* (elderly-male role) and *chou* (role of clown) appeared in the shadow play, borrowed from Peking Opera.

The shadow play is commonly seen in rural areas in North China and the provinces of Sichuan, Hu'nan and Hubei, where different local schools were formed, each with rich local flavor of their own, among which outstanding examples are the Shaanxi shadow, Tangshan shadow and Longdong shadow.

Shadow play in Shaanxi is plain and simple in figure shape, exquisite in workmanship and very decorative. It is subdivided into two kinds: the eastern route and the western route. The eastern route silhouette figures are small in stature, characterized by delicacy and ingenuity, whereas the western route ones are more bold and simple in shape.

In the Tangshan shadow play, the figures are carved from donkey hide and separated into six parts joined with iron wire

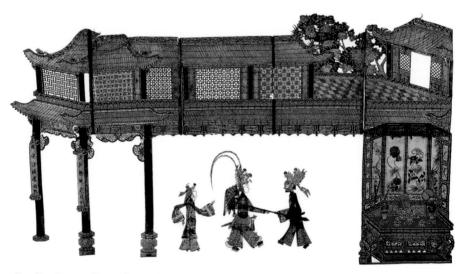

The Qing-Dynasty Shaanxi Eastern Route shadow play *Fengyi Pavilion* is particularly exquisite in its detail, featuring richly ornamented arbors, pavilions, and terraces.

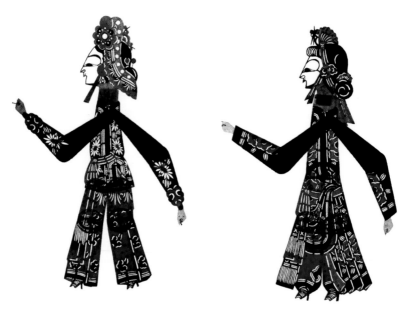

Shadow play *The Story of White Snake*, Qing Dynasty, Tangshan, Hebei.

and silk thread so that they are easily turned around. As three sticks are fixed on each figure, the puppet can be made to move realistically.

The Gansu Longdong shadow play became popular as early as the dynasties of Ming and Qing. Its figures appear exaggerated with a large head and a small trunk, the upper half narrower than the lower, the arms reaching down over the knees. The coloring of facial make-up is basically the same as that of Shaanxi opera, that is, black symbolizing loyalty, white treachery, red uprightness, painted bravery, blank honesty. Other props such as tables, beds, animals, plants, and so on are left a bit vague so as to make the chief figures prominent. In preparing silhouette figures the hide of a young black ox is chosen as the material. First a draft is drawn on the hide, which is then carved with different types of cutting tools, and colored with transparent coloring

agents which are not blended.
The last step is ironing, which
is the most important as well
as difficult part. The silhouette
figures so prepared, when dried
in the air, can be arranged for
performance on the stage.

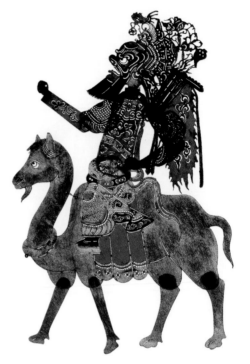

Qing-Dynasty shadow play: *Prince White Dragon*.

Commercial Arts

Shop Signs

In China, shop signs are of two major types: one is the sign board on which the name of the shop is written; the other is the trade sign, giving the line of business. The sign board is usually in the shape of an oblong wooden board and the trade sign often shows the commodity sold, whether goods or services, by means of images.

Up to the Song Dynasty, shop signs were used chiefly in restaurants and teahouses, but gradually also drugstores, draperies, pawnshops, hotels, and tobacconists started to hang a piece of cloth in front of the door showing their trade. The painting *Pure Brightness Day on the River* displays a prosperous and noisy scene of the streets in the capital, on which rows and rows of stores carrying shop signs of various types can clearly be seen.

By the time of the Ming and Qing dynasties, the growth of market-place commerce gave rise to the widespread use of four types of shop signs: image signs, written signs, material object signs and symbolic signs.

The image sign refers to the models of the commodities sold in the shop. In a tobacconist, an enlarged tobacco leaf and a tobacco pouch were drawn on a piece of cloth or a wooden board; in a shoe store, a model of the sole of a shoe was displayed.

In written signs, words were written or engraved as the shop sign, either single-type or compound-type signs. The single sign was simple and clear at a glance, such as a big character

Inscriptions often appear on wine-shop banners.

Shop sign of a Neiliansheng Shoe Store opened in the reign of Emperor Xianfeng in the Qing Dynasty. The sign is made of wooden board, bearing the name of the shop and a drawing of a boot and a shoe.

Signboard of a worsted shop using lamp-shaped signs composed of interlocked worsted rings.

"pawn" indicating a pawn shop, and a character "pickle" referring to a sauce and pickle shop. The compound-type sign gave first place to figures accompanied by corresponding words. For example, in the Chongwenmen Street in Beijing in the last years of the Qing Dynasty, shops dealing in oil baskets used real oil baskets as signs, with a big character "oil" written on the basket. The signboard was usually made of wood, in the shape of a rectangle, square or bottle gourd, coated with black lacquer on both sides and sometimes covered with gold foil to make it more conspicuous.

The "real object sign" refers to the sample goods hung at the door of a shop, such as worsted of all colors, leg wrappings, odd bits of cloth and such like to denote a draper's.

The symbol sign was originally an abstract token of the shop, something like a present-day logo, which was accepted by the public in the passage of years and became the sign of the shop.

Shop signs were made chiefly from paper, cloth, leather, bamboo, wood, aluminum, iron, and copper and tin, chosen according to the nature of the commodity, and the scope and features of the business. They were made by wood carving, embroidery, iron sheet galvanizing, weaving, and other processes depending on the materials used. Traditional Chinese calligraphy, painting, and modeling are often used in designing shop signs to give a rich folk flavor and unique national style. Different nationalities tend to use the totem they worship for major patterns on the signboard. For instance, as the Han people set great store by dragons, the horizontal bar of the sign board

is often carved in the shape of a dragon.

The art of the layout and decoration of shop signs calls for symmetry. Therefore, signs are usually placed on either side of the shop to give a balanced effect. To maximize visibility, signs are displayed in different forms, some fixed on a stone base, some hung under the eaves, some written or drawn on the wall, doorpost or lintel of a door, and some sticking out to the street on a long pole. In coloring, red, yellow, blue, black, and white are most popular, in particular red or yellow, which symbolizes auspiciousness and jubilation. In decorative patterns, auspicious symbols such as coins, dragons, clouds, and the character *fu* (blessings) are preferred. In addition, the cross bar on which the shop sign is hanging is often made into the shape of dragon or bat to symbolize "soaring like a holy dragon" or "good luck descending upon the house."

Merchants in traditional Chinese society mostly held in awe the God of Wealth and the founders of their business. The reverence for their shrines, statues and spirit tablets extended to the shop signs. In the eye of the merchants, shop signs were symbols of "treasures coming into the house," and "fortune rolling in." There are various taboos in the use of shop signs. For example, the shop signs are not "hung up" but "invited," because the character *gua* (hang up) is believed to be unlucky.

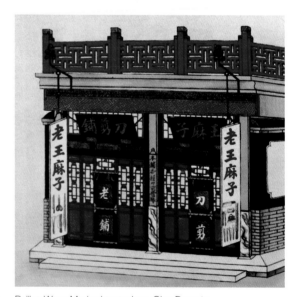
Beijing Wang Mazi scissors shop, Qing Dynasty.

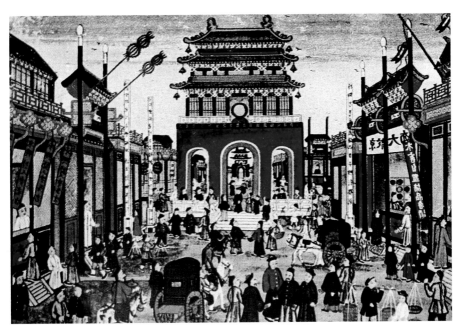

A thriving scene on Qianmen Street in Beijing during the Jiaqing and Daoguang reign of the Qing Dynasty.

Similarly, a shop sign falling on the ground is also considered unlucky, because the God of Wealth might be offended even by such a petty thing. From this, we can see the folk ways and social conventions behind the traditional handicrafts.

Packaging

Traditionally, packaging in China is always both "for the convenience of the users" and "pleasing to the eyes." In earlier days, natural materials were used in packing: tree leaves, bamboo, lotus leaves, palm leaves, gourds, coconut shells, shells of shellfish and animal skins. Later on, man-made materials were used, including fabrics, ceramics, metals, lacquer ware, wood ware, jade ware and paper. As early as the late years of primitive society, packaging had already started. Bamboo tubes,

gourd shells, coconut shells, and earthen jugs were used to hold liquids; baskets made from bamboo or willow twigs were used to hold solid objects. Sometimes commodities were wrapped in bamboo leaves or lotus leaves.

The pottery ware that emerged in the Neolithic Age was the first great invention of man-made packaging materials. By comparison with natural materials, they have the advantages of being durable, antiseptic, and insect-repellant. They are also suitable for long-distance transportation and can be made into a large number of different shapes. The earliest food cans were discovered in China—the twelve airtight food cans unearthed in Baoshan, Hubei, dating from 316 BC These cans were tightly sealed with multi-layer materials such as straw mats, bamboo leaves, and wet clay. Individual cans were encased in bamboo baskets with a handle above for convenient carrying. The outermost layer was covered in silk, before they were tied up with thin bamboo strips or silk ribbon, sealed with clay, and labelled with a description of the food contained in the can. By this process the food could be kept for a long period of time without going bad or discoloring.

In the Shang and Zhou dynasties, bronze vessels were commonly used as packaging material to hold alcoholic drinks,

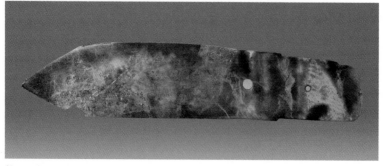

Shang-dynasty jade dagger-axe (Palace Museum). Over time, the silk and hemp fabric packaging has become stuck to the surface.

Han-dynasty lute (Palace Museum). A lute is a seal of dried clay with stamps on it, used for sealing bamboo-slip letters.

meat, and other fresh goods. Other packaging materials included earthenware, lacquer ware, wood, leather, silk and bamboo, which were also used as containers.

In the Spring and Autumn and Warring States Periods, trade competition increased and some merchants took special care with the packaging of commodities in order to attract customers. The ever-increasingly exquisite packaging sometimes caused the secondary to supersede the primary. An ancient Chinese fable entitled *Selling the Casket without the Pearls* is included in the classic *Han Fei Tzu*. A native of the state of Chu was selling pearls in the State of Zheng. He had a box made of rare wood, scented it with spices, and inlaid it with jade and other precious jewels. The result was that the men of Zheng were eager to buy the box, but returned the pearls to him.

Paper is the second significant invention with respect to man-made packaging materials. Before Cai Lun (?–121) made what was to be known as paper in the Eastern Han Dynasty, ancient paper on which maps were drawn had already appeared in the Qin and Han dynasties. By the Western Han Dynasty, bronze mirrors were wrapped with rough paper made from bamboo and hemp fibers. Improved paper was soon used in packaging articles for everyday use such as food and medicine. Henceforth paper has become the most common and important packaging

Qing-dynasty brocade: case of scroll painting *Wei Hu Huo Lu* (a painting depicting Emperor Qianlong hunting deer at Chengde Summer Resort), 36 cm long, 6.5 in diameter (Palace Museum)

material. In the Tang tombs in Astana, Xinjiang, a traditional Chinese medicine called "weirui" pills were found wrapped in a small piece of square white hemp paper, on which is written, "take 15 pills each time on an empty stomach before going to bed." When printing was invented in the Song Dynasty, the technique of package printing was soon developed and applied. The combination of paper-making and printing, in addition to the application of traditional Chinese arts such as poetry, painting, calligraphy, and seal-engraving, ensured that traditional packaging displayed a rich national flavor in decoration and external appearance. Additionally, following the

Scroll painting case (detail).

development of lacquer craft, lacquer vessels used as packaging material prevailed in the Han Dynasty and have since been a major packaging material.

In the Sui, Tang, and Song dynasties, the Chinese economy remained stable and thriving; cultural and economic exchanges with foreign countries occurred frequently. Many ceramic shapes and designs were influenced by Western objects. When earthen and china cups, bottles, and jugs were used to hold wine or vinegar, customers were often attracted by the tasteful packages. Even the wine and vinegar contained in the vessels benefited from it and sold at a higher price. On the outer packages of some commodities, places of production and names of shops were marked so as not only to ensure genuine goods at a fair price, but also to prevent inferior or fake commodities from passing off as genuine.

In the Ming and Qing dynasties, with the emergence of capitalism, the people's commodity consciousness intensified, as lacquer and silk cases used for packaging became more and more elegant and sumptuous. Packaging itself seemed to become a form of art in which the most typical was the packaging of articles for the use of the royal court in the Qing Dynasty. These were specially manufactured, some by the imperial workshops and some by folk craftspeople. The former embodies typical royal style and characteristics of the times in choice of materials, design and

Qing-dynasty Pu'er tea parcel containing five small tea bags wrapped in bamboo leaves, a local packaging method still in use today.

Jingdezhen china bowls wrapped with straw rope.

ornamentation, whereas the latter gives expression to practical use, with ornaments that are designed to fit the taste of the imperial family. Needless to say, the materials used in the royal workshops are largely red sandalwood, lacquer ware, enamel, bamboo carvings, sold and silver inlaid vessels, and silk fabrics, and the decorative skills include carving, engraving on gold and silver, painting, inlaying, baking and weaving, displaying the superb achievements of Qing-Dynasty arts and crafts.

Legends related to arts and crafts

In ancient times, the Chinese people held that all sorts of articles used in daily life and production were the creations of sages. The *Kao Gong Ji*, a text from the pre-Qin period, explained the plain doctrine of sages' creation of articles: "Sages create articles and skillful people state them and observe them. They are called handicraftsmen. All things related to handicrafts are done by sages." According to the handicraft legends that have passed down from generation to generation, the right of earliest handicraft invention often belonged to those sages with deities' means or saints' ways, such as tribal chieftains, emperors and queens, or certain subjects. That is why there are a series of legends about how those very intelligent sages became the earliest handicraftsmen. For example, Emperor Xuanyuan (the Yellow Emperor, a legendary ruler of China in remote antiquity) is thought to have invented armor and helmets, boats and vehicles, hats, crowns, and clothing; Youchaoshi built nests with timbers and initiated rooms and houses; Emperor Xuanyuan's wife Leizu was worshiped as goddess of silkworms, as she taught the women of her time to pluck mulberry leaves and feed silkworms; Fuxishi invented the fishnet, the *qin* (a seven-stringed plucked musical instrument) and *se* (a twenty-five stringed plucked instrument); Emperor Yan invented the *lei* (ploughs) and *si* (plowshares); Zhou Gong invented the *zhinan che* (a vehicle pointing south); Meng Tian of the Qin Dynasty invented the writing brush; and Cai Lun of the Han Dynasty invented paper-making.

Most of the earliest legends about handicrafts initially circulated orally among artisans of the same trade and were then disseminated through society. During their passing down from generation to generation, the legends were continuously enriched and perfected, becoming ever more beautiful and touching. They were either about the origin of the different trades and their unique characteristics, or about the earliest

master artisans who started the trade, or about how craftsmen bravely faced a hard life and miserable sufferings. It may be said in a certain sense that the legends about handicrafts are used to praise those skilful craftsmen and artisans little known in past ages.

Legends about handicrafts were passed down both orally and in books, though even the latter versions became increasingly divorced from the original historical record and took on a more legendary character.

Yanshi and his Puppets

In the Western Zhou Dynasty, when King Mu was on the throne, there was an artisan named Yanshi. The puppet he made bore a strong resemblance to a living person. At first, King Mu thought the puppet was Yanshi's attendant. When Yanshi gave orders for him to advance, retreat, bend forward or backward, it responded exactly like a human being. When opening its jaws, it could sing; and when moving its arms, it could sway and move about as in a dance. When the performance came to an end, the puppet cast seductive eyes on King Mu's favourite concubine. King Mu flew into a great rage, firmly believing the puppet, dexterous and quick in action, must be a real being instead of a puppet, and wanted to put Yanshi to death on the spot. Yanshi immediately disassembled the puppet to show that the puppet was made of no more than leather, wood, gum and lacquer, and black, white, red and blue pigments. King Mu hastened forward and examined the doll carefully, finding it had all organs, muscles and bones, joints, skin, hair and teeth. However, they were all man-made. When they were assembled together, it became a living puppet again. King Mu gasped in admiration of Yanshi's superb skill, very pleased and sincerely convinced.

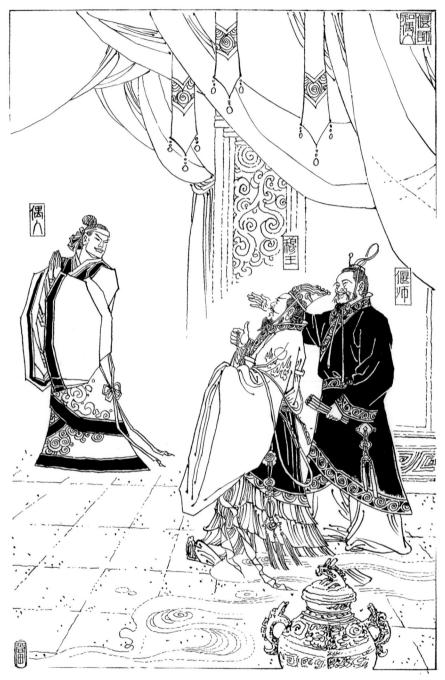

The miraculous puppet made by the artisan Yanshi greatly surprised King Mu of the Zhou Dynasty.

Lu Ban, a Carpenter Consecrated by Artisans of all Crafts

Lu Ban, also known as Gongshu Ban, was a renowned carpenter of the Lu State during the Spring and Autumn Period and the Warring States Period. The social changes of this time helped artisans gain some freedom and the widespread use of ironware provided favorable conditions for the development of handicraft technology. In tool innovation and workmanship, Lu Ban found his own way to distinction. Ancient books recorded his innovation and fabrication of various kinds of utensils for daily use, such as the *yinkuo* (an appliance used for straightening out lumber) and shovel. Lu Ban was originally a carpenter but legend has it that he was also engaged in other trades, as a coppersmith and stonemason. According to the legend circulated in the Han Dynasty, Lu Ban was said to have carved and painted the crossbeams of the palace in Luoyang and built a bridge in the vicinity of Chang'an. Afterwards, this kind of legend increased day by day and people did not take too much notice whether these legends were in conformity with Gongshu Ban's history during the Warring States Period; instead they took Lu Ban as the ideal character of a skilled artisan. For the promotion of their respective professions, many tradesmen such as carpenters, bricklayers, stonemasons, shipbuilders, and vehicle manufacturers, all consecrated Lu Ban as the founder of their respective trade.

The Legend of Ganjiang and Moye

During the Spring and Autumn Period and the Warring States, the iron abounding in the Yue State was the best in quality and sword-making masters emerged in large numbers, among whom Ganjiang was a man of great reputation. Ganjiang moved to the Wu State and was married to Moye. As He Lü, the king of

the Wu State, was fond of double-edged swords, the two of them were appointed to an official position. For casting an excellent sword, the king of the Wu State sent someone to acquire the best iron from the Yue State and ordered Ganjiang to create a unique sword within three months or he would be beheaded for disobeying the order. Ganjiang and Moye went on working hard night and day for two months, but the iron was still not melting in the furnace. The deadline for the sword was due soon, but they were at their wits' end. Ganjiang brought up the story about how his master worker and his wife jumped into the furnace so that the iron was melted and a good sword was made within the deadline set by the king of the Yue State. After hearing the story, Moye decided to sacrifice her life for the sword. After turning the issue over in his mind for a long time, Ganjiang suggested that, as hair and nails of human beings were the parents' essence, maybe they could melt the iron. So Moye cut off her long hair and nails and threw them into the blazing fire. Simultaneously, three-hundred young boys and girls did all they could to air-blast the furnace with more charcoal added to the blazing fire. In an instant the iron melted and a couple of unique "male and female swords" in the world was finally wrought. The male sword, covered with lines in tortoise-shell pattern on the surface, was named Ganjiang

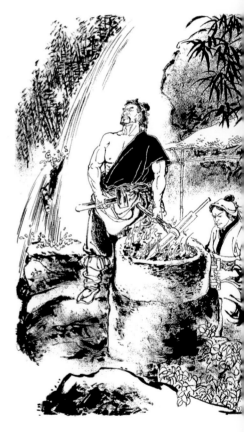

Ganjiang and Moye, masters of sword casting, tempered double-edged swords in blazing fire day and night.

while the female sword, covered with lines in a water-wave pattern on the surface, was named Moye.

However, the legend had several different versions. In the *Wu Di Ji* (*A Record of the Wu State*), the swords were not wrought until Moye jumped into the furnace. The *Lie Yi Zhuan* (*Stories of Supernatural Beings*) and the *Shou Shen Ji* (*Stories of Searching for Deities*) even added a child for Ganjiang and Moye to show the artisans' strength through a complicated plot of vengeance. Ganjiang offered the king of the Wu State only the female sword and concealed the male sword for himself. When finding the truth, the king of the Wu State put Ganjiang to death. When growing up, Ganjiang and Moye's son Mei Jian Chi tried to avenge his parents but the king of the Wu State was on strict guard against assassination. Thanks to the help of a swordsman who promised to avenge him, Mei Jian Chi handed the male sword to the swordsman and then committed suicide by cutting his own throat. Pretending to be offering the male sword and Mei Jian Chi's head, the swordsman managed to access the king and finally perished together with the king of the Wu State.

The Legend of Brother Kilns

The Longquan celadon is one of the notable varieties of the traditional ceramics of China. In legend, two brothers, Zhang Shengyi and Zhang Sheng'er, of Longquan County, Zhejiang, improved celadon in the Southern Song Dynasty. The legend has it that the Zhang family had been engaged in porcelain-making from generation to generation. According to their father's last wish, the two brothers ran their own kiln and tried hard to make innovations. Beginning with colors, Zhang Sheng'er analyzed seriously all the colors man could see in the sky and on the earth and came to the conclusion that cyan was the basis of all colors, the essence of all colors and the most beautiful color, as it pleased both the eye and the mind. After

discussion, the two brothers decided to take cyan as the fixed color of the Zhang family to make porcelain. When he happened to see a green plum tree standing gracefully erect by the kiln shed, Zhang Sheng'er thought the cyan of plums was the most beautiful cyan. Plucking the plum leaves together with small plums, he had them simmered into thick juice, blended it into glaze and applied it onto the porcelain base. Finally celadon, which was bluish, came into being and caused a great sensation. After seeing it, Emperor Gaozong (1127–1131) of the Southern Song Dynasty was so delighted with it that he could hardly bear to put it down and he issued an imperial decree to change the porcelain kiln of Zhang Sheng'er into a government-run porcelain industry and conferred the title of the "Diyao Kiln" (The Younger Brother's Kiln) upon it.

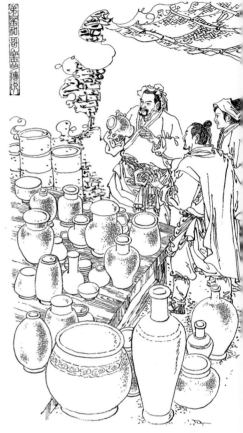

The two brothers, Zhang Shengyi and Zhang Sheng'er, worked hard to improve celadon technology.

Zhang Shengyi also cherished high ambitions in his life, trying to create a kind of crackle porcelain, which had always been believed to be something bestowed by deities, as an artifact. In order to uncover the secret of crackle porcelain, he kept to himself and never got married. After serious studies and investigations, he found that to gain a few pieces of crackle porcelain the people of his time often threw a living person into the blazing kiln. The blood and moisture of the

living person caused the crackling of the porcelain. When the blood congealed, the color was purple. That is why the color of crackle porcelain was always a little blood red. When the porcelain base hit moisture, there was no time for it to shrink and hence crackling occurred in a polygonal shape. As Longquan had a special kind of clay with the color of a blood red, the key issue was the moisture level and the right amount of water injection. Zhang Shengyi persisted in doing contrast tests but failed again and again. Once in a severe winter, when taking a bowl of noodle, to him, his brother's wife Wu Zhenzhen found him injecting water into the kiln. Thinking that her brother-in-law was trying to put out the fire in the kiln, she lent him a hand. Unexpectedly, a kiln of crackle celadon full of fish-scale cracks came out, seeming cracked but not broken. Indescribably wonderful crackle porcelain! Zhang Shengyi's crackle celadon created a sensation in both the court and the masses. Immediately, his kiln became one of the five famous kilns of the Song Dynasty and its products were put exclusively to use in the imperial palace and for export. As Zhang Shengyi was the elder of the two brothers, his crackle celadon was also named the "Geyao Kiln" (The Elder Brother's Kiln) celadon.

Origin of *Kesi* Silk

Kesi silk is a variety of Chinese silk weaving, complicated in workmanship but rich in expression. When the troops of the Jin Dynasty went south to invade the Song Dynasty, a youngster named Qiaosheng at Likou, Suzhou, lived on weaving *juan* (a kind of thin and tough silk) but due to the chaos caused by the war he had to change his occupation to trade rags with sweets. Once he found a piece of old fabric with the same flower-and-bird pattern on both sides, looking neither like brocade nor like embroidery, and the pattern was very soft and pleasing to the

eye. He decided to learn this kind of workmanship. One day by a lotus pond Qiaosheng helped a girl retrieve clothes washed away by the water. To express her thanks, the girl gave him a lotus seed. On returning home, he put the lotus seed into a vat and it began to put forth lotus flowers of various colors. All of a sudden, he found the girl in the lotus vat weaving silk cloth. The girl wrung juice out of the lotus flowers and lotus leaves she had gathered and dyed the fibers of the lotus root into different brilliant colors. Then she made little and dainty shuttles one after another with pointed bamboo leaves. She loaded the lotus fibers of different colors, from light-colored to deep-colored, into the shuttles and arranged them in alignment in front of the loom. The fiber of the lotus root in the shuttles turned into silk fiber. She changed the shuttles one after another, weaving in a very meticulous way. Qiaosheng was so surprised that he jumped out from behind the door. Knowing that her secret was discovered, the girl stayed at Qiaosheng's home and passed on her skill to him. They named this kind of weaving method "hesi," meaning the silk woven jointly by them. As the people of Suzhou pronounced the word "he" as "ke," people called it "kesi silk" afterwards.

Gourd-Shaped Porcelain Canteen and Yue's Troops

At the end of the Southern Song Dynasty, there was a kiln artisan named Hulu at the Cizhouyao Kiln. He was clever and skillful. Once he made a kind of porcelain canteen, thick at both ends but thin in the center, convenient to carry. As it looked exactly like the gourd used by immortals in legend, people called it porcelain gourd, also known as the canteen of the Yue's troops. The legend goes that to recover the occupied territory in the north, Marshal Yue Fei led his army from the Yangtze River all the way to Mount Taihang. The kiln artisans

Artisans from the Cizhouyao Kiln present a porcelain canteen to Yue Fei.

of the Cizhouyao Kiln were very excited and tried to present Yue's troops with a kind of porcelain canteen in the shape of a kidney for them to carry conveniently on the march. The kiln artisan Hulu thought he should send Marshal Yue and his troops a precious canteen just like that used by Taishang Laojun (the Very High Lord in the legend) to hold the elixir of life, as Marshal Yue had rendered outstanding service to the Song Dynasty. It was said that the water used to blend the clay for making the treasured canteen of the Very High Lord was taken from nine rivers and eighteen lakes. So he sent someone to take the spring water from nine springs, including the Black Dragon Spring, the Yellow Dragon Spring, the Dark-Green Dragon Spring, the Old Dragon Spring and the Jade Dragon Spring. In the clay to make the canteen, he added costly medicines, such as musk, glossy ganoderma, bezoar and peppermint. Finally, when the canteen was used to hold water or wine, not only could it quench thirst and relieve summer heat but also cure all diseases.

The officers and men of Yue's troops went on with the march using the porcelain canteen, sweeping northward from victory to victory. Afterwards, due to the collusion between Qin Hui and the Jin troops, Yue's troops were besieged on the top of Mount Jiushi. Before long all the water bottled in the ordinary porcelain canteens was drunk up but the officers and men found to their surprise that the water and wine in Marshal Yuan's porcelain canteen would never run out. They found some big Chinese characters "Porcelain Canteen with Water from Nine Springs" and some small Chinese characters "Cizhouyao Kiln" inscribed at the bottom of the canteen. The officers and men drank freely with great joviality. After drinking the wine to their heart's content, the Yue's troops rushed down the mountain and recovered a large stretch of territory.

Qiu Changchun, the Forefather of Jade Carving in Beijing

Qiu Chuji, also known as Taoist Changchun, was the earliest jade worker in Beijing and was called Ancestor Qiu by artisans. Ancestor Qiu was born to a poor family in a town in Shandong at the end of the Southern Song Dynasty. Not far away from his home, there was a small jade workshop, where he became an apprentice and learned the skills of jade carving. Due to this father's early death from illness, Ancestor Qiu discontinued his apprenticeship. Later, during the chaos caused by war, he could survive only by carrying people across the river on his back. At the riverside he happened to meet a Taoist priest. On seeing that the young man was intelligent with natural talents, the Taoist priest accepted him as a disciple and let him roam everywhere to study jade ware as his main job so that he could learn skills and help the distressed. Afterwards, Ancestor Qiu had the opportunity to tour around China to those places rich in jade, such as Xinjiang. He learned how to look at a piece of jade and judge its worth and studied hard to master various kinds of artisan skills.

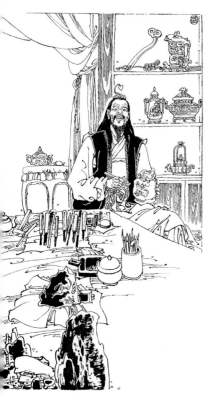

Qiu Changchun studied intensively to perfect jade-carving technology.

After the Yuan Dynasty founded its capital in Beijing, Ancestor Qiu came all the way to Beijing through the northwest and settled down at the Baiyun Guan (The White Cloud Taoist Temple) to devote himself to jadeware. His nationwide touring widened his field of vision. By drawing on other people's talents and making use of the knowledge passed on

to him by the Taoist priest, every piece of jadeware he fabricated was exquisite. Not only was Ancestor Qiu proficient in jadeware himself, he also passed on his jade-carving skills to others in accordance with their aptitude. With his support, the jadeware trade came into being in Beijing and the Baiyun Guan became an institute for Ancestor Qiu to pass on his skills.

Gong Chun Teapot and Lotus-and-Toad Teapot

Yixing, Jiangsu, is known as the "pottery capital with a history of a thousand years" and the fame of the *zisha* (purple-clay) teapot of Yixing has spread throughout the country. If someone asks who made the greatest contribution to the *zisha* teapot craft, all the local people would unanimously give credit to Gong Chun and tell the story of the lotus-and-toad teapot he made.

By the Ming Dynasty, the pottery-making industry of Yixing had already reached a fairly large scale. At Yixing there was a farmer surnamed Gong and his only son was named Gong Chun. From childhood, Gong Chun liked to watch his neighbor, an old monk, make pottery. But as the old monk was afraid of losing his own livelihood by passing on his skills to the boy, he was unwilling to teach him. So Gong Chun could do nothing but study intensively by himself. One night, when he saw an unusual shadow cast by the moon on the knot of a peach tree, he had the inspiration to make a *zisha* teapot with the peach tree knot as the teapot body. As the shape of the teapot was natural, it was simple and unsophisticated, and a new *zisha* handicraft was born, which the people named the "Gong Chun teapot" after its inventor. The greedy magistrate of the local prefecture asked Gong Chun to make a teapot for him. Gong Chun hated to fawn on and flatter influential officials but this time he made an exception to accommodate him. In the end, he made a lotus-and-toad teapot with the magistrate as the model. The toad opening its big mouth was the very image of the magistrate. This lotus-and-toad teapot

was not only a masterpiece of the *zisha* teapot but also a scathing satire on those influential officials avaricious of wealth.

The Beauty Offered for Sacrifice

There is a legend about a famous variety of porcelain named "ji hong" (the red for sacrifice). The color of "ji hong" is sleek and glossy. It is the top-grade red glaze porcelain and the most precious kind was produced in the Ming Dynasty.

The legend goes that in the Ming Dynasty, the royal porcelain plant in Jingdezhen received an imperial edict to make a special kind of porcelain. In case of failure to make the deadline, the punishment would be the death penalty. As the kiln could not reach the temperature needed, the old pottery artisan in charge failed again and again. He sighed and groaned at home and his daughter worried very much for her father.

On the following day at noon time, the old artisan's daughter, all dressed up, brought lunch to the plant for her father. As the temperature in the kiln was still not high enough, all the people present were too sorrowful to eat anything. All of a sudden, the artisan's daughter shouted, pushed aside the people around her, and jumped into the kiln. Just at the time when everybody was crying and yelling, the temperature in the kiln went up and the porcelain required was made. As the old artisan's daughter saved everybody, the later generations call this kind of porcelain "the beauty offered for sacrifice."

Legend about Ceramics with Multicolored Glaze

This legend is about the return of a prodigal son. An artisan proficient at porcelain craft named Zhao Dacheng at the Cizhouyao Kiln in Pengcheng Town had two sons. The first son, Zhao Dechang, was not only kind-hearted but also extremely skilful in handicraft while the second son, Zhao Debao, was, on the contrary, gluttonous and lazy, unwilling to learn any skill.

After dividing up the family property and moving apart, the good-hearted elder brother gave the better kiln to his brother and took a worse one for himself. However, due to the superb porcelain technology he had learned from his father and his diligent work, his kiln was flourishing while his brother almost brought ruin to the better kiln. Stirred up by his wife, the younger brother went to his elder brother's kiln at midnight, trying to destroy it out of jealousy. He sneaked into his elder brother's workshop and dumped bricks and other things into the glaze vat and stirred them up hard, giving vent to his depressed and discontented feelings. Unexpectedly, the elder brother produced a kiln of ceramics with beautiful multicolored glaze without knowing the cause and had no idea how to repeat the unexpected success. Afterwards, the younger brother was repentant of his fault and started to study hard the technique of multicolored glaze. After numerous failures, he finally succeeded and created a brilliant multicolored glaze that looked like floating clouds and flowing water, resplendent with variegated coloration.

The development of the cool bottom of the bowl

An emperor once took a fancy to the celadon bowl produced in the Cizhouyao Kiln, but he hated the bowl bottom that burned his hand when holding it, so he ordered pottery artisans to improve porcelain bowls so they would not burn the hand in ten days. A pottery artisan named Wan'er took the task on his own initiative. When ears were added, the bowl became a jar; and when a handle was added, it became a pot. Neither way helped to solve the problem. One night when he was so sleepy that he fell asleep at work, the candle burned the collar of his ragged cotton-padded coat. His mother came over trying to stamp out the fire but the more she stamped, the higher the flame went. When waking up with a start, Wan'er found his mother standing on his burning coat with her soles smoking. In

a grasp, he carried his mother to the edge of the *kang* (bed) and took off her shoes. To his great surprise, he found that neither her feet nor her shoes were burned because of the wooden soles studded at the bottom of the shoes. Inspired by the wood-bottomed shoes, Wan'er succeeded in working out a bowl with a pad that very night so that when one held the bowl the hand would not be burned. Afterwards, other pottery artisans thought the solid bowl bottom was too heavy and unattractive, so they used a ring-shaped bottom instead to achieve a better effect of thermal isolation.

The legend has another version in the locality. In the Ming Dynasty, when passing by Pengcheng, the king of the Yan State took a liking to a glittering flowered bowl but his hand was burned by its bottom when holding it. Thus he issued an order to have a bowl made within five days that would not burn the hand. Nie Wansan, a superb handicraftsman in the town, accepted the task. At night, on seeing the crescent moon against a faint cloud, oblate in shape, he was inspired. The idea struck him that if two crescent-shaped clay strips were stuck to the bottom of the bowl, they would help to isolate the heat to a certain extent and the hand holding it would not be burned. Henceforth, the bowl of Pengcheng had a bottom. Later, other pottery artisans changed the two separated clay strips into a ring so that the effect of thermal isolation was much improved.

Origin of Wax Printing

The people living in many Miao nationality areas in China are still singing an ancient song "The Song of Wax Printing" about the origin of wax printing. Long, long ago, according to a legend, a clever and beautiful Miao nationality girl was discontented with single-colored clothes and wanted to print various beautiful flower-and-plant patterns on her skirt. However, the craft of that time could only paint patterns by hand on skirts one by one. She

was at a loss what to do and felt depressed. One day, on gazing at the hills full of fresh flowers, the girl was absorbed in meditation and fell into a trance, sinking into a deep sleep. Secretly, a flower fairy, beautifully dressed, took her to a garden with singing birds and fragrant flowers, dancing butterflies and busily working bees. The girl was so fascinated by the beautiful scene that she had no idea at all that the bees were crawling on her dress. When she came to her senses, she saw spots and stains of honey and wax left on her clothes. Putting her coat and skirt into a bucket for dyeing indigo, she tried to dye them once again so as to cover the wax stains. After dyeing, the girl put her dress into boiling water to rinse out the floating color. When she took out the clothes, a miracle occurred before her eyes. Beautiful white flowers appeared on the dark blue coat and skirt where they had been stained with wax! A bright idea occurred to her. At once, she took some wax and melted it by heating first and then drew some flower patterns on a piece of white cloth with a twig. After that it was dyed in indigo liquid and finally when the wax was melted away by boiling water, white flower patterns appeared on the cloth. The girl was so happy that she sang a folk song. On hearing the resounding song, the countrymen, far and near, all came to see the skirt with flower patterns she had dyed and learned from her the skill of how to draw flowers and patterns on cloth. With this skill they dyed a great variety of cloth. From this time on, the technique of wax printing has been spread and handed down in the Miao nationality and the other fraternal national minorities living with them such as the Bouyi nationality and the Yao nationality.

Bodiless Lacquer Ware Created by Shen Shaoan

During the Qianlong regime in the Qing Dynasty, there was an ordinary lacquerer named Shen Shaoan running a shop by the Shuangpao Bridge. He was engaged mainly in lacquer

painting but also in making small commodities like lacquer ware, lacquer bowls, and memorial wood tablets. As his business was slack, Shen Shaoan often went to those imposing dwellings and spacious courtyards of officials and officers or Taoist temples and Buddhist temples to do lacquer painting work. Once, when he was working in an ancient temple, he found the wood of the horizontal inscribed board of the temple at the entrance had already rotted, but the body inside, mounted with lacquered linen, was still intact. Shen Shaoan was a man careful enough to take some inspiration from this. He first molded figurines, flowers, birds or utensils with clay and then coated them with lacquered linen or silk fabric layer by layer. When the fabrics coated with lacquer on the mold were dry, he drilled a hole at the bottom of the mold and then immersed it into water to dissolve the clay body. The last step of this workmanship was to polish the hardened fabric shell and to coat it with different colors of lacquer. Thus bodiless lacquer ware was made. Shen Shaoan became the earliest artisan to make bodiless lacquer ware in Fuzhou. It is widely popular for its advantages, hollow in body, light in weight, decorative to look at and durable in use. From then on, the bodiless lacqureware of Fuzhou, together with the cloisonné enamel of Beijing and the ceramics of Jingdezhen, Jiangxi, have been called "the three treasured objects of the traditional arts and crafts of China."

The Book of Changes, completed in the Zhou Dynasty, already stated that a large number of articles beneficial to national welfare and the people's livelihood were created by sages, expressing the view that all articles were created by sages and all crafts were for the purpose of practical use. The *You Xue Qiong Lin* (an enlightened text widely circulating among the people at the turn of the Ming and Qing Dynasties) explained the beauty of utensils, skills and arts and crafts like this: "It seems that unusual skills are unbeneficial to people while handicrafts are helpful for

practical purposes." The idea at its core is also to lay emphasis on practical purposes and uses.

The legends about folk arts and crafts are also obviously affected by the idea that the perfection of utensils is not the ultimate end and that only when a utensil serves the purpose of use can it be said to have a high value. Of course, it is also related to the form of passing on and carrying on the ancient arts and crafts of China. The traditional way of passing on skills in China was the training of an apprentice by his master. However, due to the conservative ideas of handicraft trade, masters would often hold back some more advanced techniques so as to ensure the continuance of their own means of livelihood. Therefore, legends about crafts and arts were always lifted up to the height of trade worship. So far as apprentices were concerned, their psychology was not only learning from their masters and believing what their master taught them. They were also in a position of begging for skills, supplicating for patronage and praying for good luck. Those heroes or heroines in the legends who created or improved a craft were often worshipped as the founder of the trade.

The handicraft culture in the legends, as an important component part of the traditional culture of China, embodies in lively stories the ideas of practical use for all handicrafts and skills. In the vast world of the utensils for people's everyday use, these ideas have had a wide and far-reaching effect on the traditional viewpoint of the Chinese people.

Traditional Crafts in Modern China

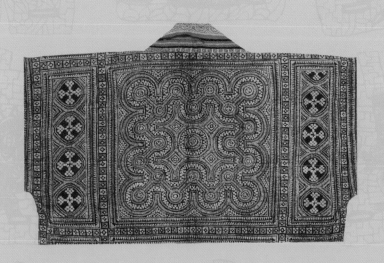

Since the founding of the People's Republic of China in 1949, great importance has been attached to traditional arts and crafts which, as an important component part of applied arts, have come to a new historical stage of development. In the light of the policy of "protection, growth, improvement," a series of activities exploring, recovering and developing traditional arts and crafts have been conducted. On the one hand, a general survey of the handicraft industry has been carried out, handicraftsmen

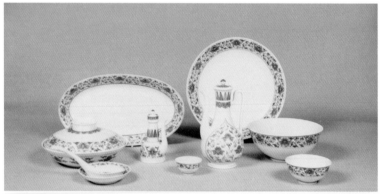

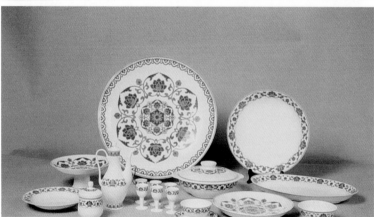

Dou-colour glazed Jianguo porcelain tableware and blue-and-white Jianguo porcelain western tableware, designed in 1954 by Zhu Danian and manufactured in Jingdezhen. Ivory carved *bust of Mao Zedong*, 7 x 6.5 cm, manufactured in the 1950s by Yang Shihui of the Beijing Arts and Crafts Research Institute. (Treasure Hall, Beijing Arts and Crafts Group Corporation).

organized to resume work, the problem of employment solved while handicrafts production developed by means of supplying materials, reducing taxes, granting low-interest loans, purchasing products, and so on. On the other hand, handicraft articles among the people were explored, collected, sorted and studied; national and international handicrafts exhibitions held, and a forum on applied arts convened. As a result, quite a number of artisans who were scattered or transferred to other trades returned to the handicrafts trade, and some businesses that had ceased resumed operation.

From 1949 to 1952, a number of pilot handicraft cooperatives were established. In 1953, the handicraft cooperation campaign entered a stage of general development and by 1956 all-round handicraft cooperation was basically realized. The cooperation campaign has helped economic recovery, and cultural protection to merge together, and thus enabled handicrafts to shift from individual to collective production. In this way, the productivity of handicrafts was rapidly enhanced, the creative environment, social status and living conditions of the artisans improved, and handicraft skills promoted, so that a great number of fine handicraft articles full of the flavor of the times were produced, such as ivory sculptures made by Yang Shihui with the Beijing Handicrafts Research Institute, and "state-founding porcelain" designed by Zhu Danian the handicraft educator, jointly baked by handicraftsmen from Jingdezhen.

State management now takes the place of the guild regulations in the past, resulting in the gradual formation of an integrated system covering "supply, production, technology, marketing, and study." In 1954, the first arts and crafts service center was founded in Beijing, engaged in purchasing fine handicraft articles discovered or produced in different places. Since then, about 280 arts and crafts service centers have been established gradually in large and medium cities and in key regions, which closely

linked up the production and consumption of arts and crafts articles in the domestic market. In 1955, the national arts and crafts gallery was founded in Beijing, which not only furnishes a place for arts and crafts workers and artisans to observe and learn, but also supplies exhibits and state presents for international economic and cultural exchanges. In 1957, the First National Arts and Crafts Workers' Congress was held in Beijing, which carried forward further development of arts and crafts in China.

In the 1950s and 60s, the education and inheritance of arts and crafts gradually diversified. First, in the collectivized factories where traditional industries including jade ware, cloisonné, sculpture, ceramics, carpet,

Ivory-carving *Bust of Mao Zedong*, 7 x 6.5 cm, manufactured in the 50s of the 20th century by Yang Shihui, handicraftsman of Beijing Arts and Crafts Research Institute. It was the first ivory carving of the bust of the state leader. The bust is accurately shaped, in dignified bearing, having penetrating eyes. Now housed in the Treasure Hall of Beijing Arts and Crafts Group Corporation.

embroidery, and knitting are involved, skills were still imparted to apprentices privately by their masters. However, there was no such relationship as personal dependence between masters and apprentices, thus breaking the ancient skill blockade practice of "keeping secret the skill by staying with the master." The apprentices respect the master, and the master in turn makes known to the public his skills. Second, collective production and machine production geared towards arts and crafts helps to harmonize the relationship between masters and apprentices, contributes to organizing training programs

and forming various new types of arts and crafts education for staff members and vocational education. Third, secondary arts and crafts schools were established, focusing on local types of arts and crafts. For example, lacquer ware and ceramics are taken as key disciplines in the Fujian Arts and Crafts School, which was founded the earliest (1952); and cloisonné, carved lacquer ware, dyeing and weaving were taken as key disciplines in the Beijing Arts and Crafts School, which was founded in 1958. Fourth, higher arts and crafts institutions were set up to train high-level personnel. In 1956, the first higher institution of arts and crafts, Beijing Arts and Crafts Academy, was founded, followed by a dozen higher institutions of fine arts where arts and crafts majors were set up. Fifth, research institutes of arts and crafts were established where veteran handicraftsmen and key technicians gathered to engage in design and study whereas creative and designing groups were set up in quite a few arts and crafts works and cooperatives. Arts and crafts journals were run by some arts and crafts schools and research institutes to stimulate exchanges and researches on arts and crafts. In 1958,

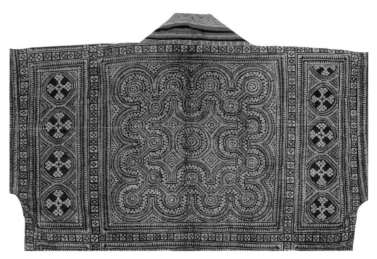

Miao minority batik blouse, 40x47 cm, Guizhou, made in the 1950s (Academy of Arts and Design, Tsinghua University).

the journal *Decoration*, the first ever formal journal of arts and crafts, was run by the Central Arts and Crafts Academy.

The establishment of a research system and the formation of modern arts and crafts education has contributed not only to the widespread and scientific explanation of the experience and knowledge of traditional arts and crafts, but also to the training of a new type of designers. Arts and crafts workers in Beijing, Zhejiang, Sichuan and Hebei, cooperating with craftsmen, have designed some new products with a local flavor including Zhejiang Longquan porcelain, Sichuan lacquer ware, and Hebei black-and-white pottery. At the same time, inherited tradition is combined with modern science and technology. There have also been new achievements in combining architecture and modern industries such as the ten major building projects in the capital, which pushes forward the creation and research of arts and crafts. For example in the Great Hall of the People over twenty thousand arts and crafts articles of all sorts are on display.

The first issue of *Decoration*, the first formal journal of arts and crafts in modern China, inaugurated by the Central Academy of Arts. The cover was designed by Zhang Ting, decorative artist and then deputy dean of the Academy. In the dragon boat in the middle of the cover are four banners fluttering in the breeze on which patterns of food, clothing, shelter and transportation, respectively, are painted, representing the different areas of life design is used for.

In 1978, China entered a new period of reform and opening-up, which favored the development of arts and crafts. In that year, the Ministry of Light Industry, Ministry of Foreign Trade and Ministry of Commerce jointly sponsored a nation-wide arts and crafts exhibition. A nationwide forum on arts and crafts creation and design was held. The forum put forward a proposal to preserve tradition, encourage innovation, to train a new workforce and enhance the market. During the next few years, multiple government initiatives promoted and celebrated

Ten Major Buildings constructed in Beijing in the 1950s
To usher in the tenth anniversary of the founding of the People's Republic of China, the Central Government launched the Grand National Day Construction Project in Beijing, building ten major public buildings including the Great Hall of the People, the Museum of Chinese History and Revolution, the Chinese People's Revolutionary Military Museum, Beijing Railway Station, Beijing Worker's Stadium, the National Agricultural Exhibition Centre, Diaoyutai State Guest House, the Chinese Ethnic Cultural Palace, Chinese Ethnic Hotel, and the Huaqiao Building. Construction of the ten buildings started on September 5, 1958 and was completed less than a year later. They soon became familiar landmarks in the city.

Chinese arts and crafts. These measures stimulated the rapid development of arts and crafts in the 1980s. In 1981 alone, the annual output value came to RMB 5.3 billion yuan, with foreign exchanges of $1.5 billion.

Since the 1990s, traditional arts and crafts have met with new challenges and thus entered a new stage of development. On the one hand, at the beginning of the 1990s, China's economic transformation confronted a complicated and changeable international environment. While trade declined internationally, sales of Chinese products suffered. A variety of products appeared lacking competitiveness in international markets; large-scaled arts and crafts enterprises in cities fell into dire straits, even closed down. Owing to intense competition in export and the growth of domestic demand, articles of arts and crafts are sold primarily on the home market. On the other hand, following the development of the market economy, private and individual businesses gradually became the principal part of the arts and crafts profession, which stimulated the development of new products.

With the development of the economy and the improvement of people's living standard, lifestyles have changed. Traditional culture was neglected for a time, with quite a number of traditional products of arts and crafts losing market share. The younger generation desired foreign goods and fashions, having no interest in traditional arts and crafts. As regards employment, the market economy and the development of modern industry require more labor and have offered workers more options. Learning handicrafts became less popular due to the decline in the social status of handicraftsmen. Even in the families of handicraftsmen whose trade

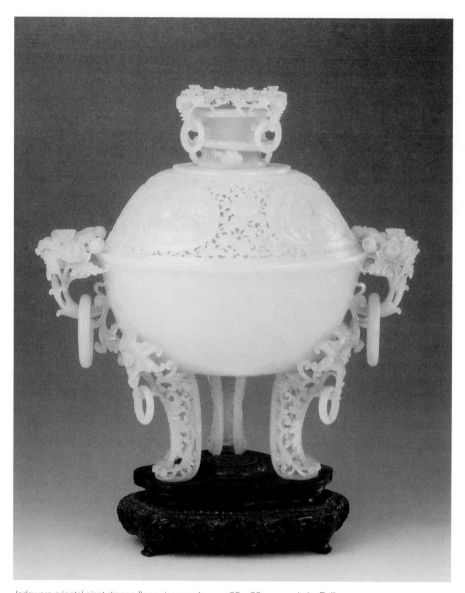

Jadeware *oriental giant dragon flower incense burner*, 35 x 32 cm, made by Beijing
Jadeware Plant, now displayed in the Great Hall of the People. The lid button is shaped like
a coiled dragon with its head held high, on the lid is a pierced flower pattern, and on the four
sides are carved portraits of Zu Chongzhi, Zhang Heng, Monk Yixing and Li Shizhen. The
handles are carved in the shape of *kuilong* (legendary one-legged dragon-like animal). Screw
sockets are carved in where the lid and button, body and ears join so that the pieces can be
connected or separated.

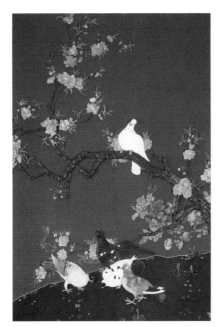

Lacquerware *Ode to Peace* wall screen, 275 x 200 cm, designed by Chen Zhifo and Jiang Bi in 1959, made by Yangzhou Lacquerware Factory, and displayed in Beijing in the Great Hall of the People. Using a combination of carving and inlay of jadeite, agate, and hibiscus jade with carved flower and bird patterns.

is passed on from generation to generation, the younger generation coming through the modern scientific education system, tend to give up the profession their parents took. Those who continue their parents' business are often doing so for economic rather than cultural reasons.

The predicament the traditional arts and crafts fell into with respect to their inheritance, protection and development has aroused the attention of the state authorities. In 1997, the State Council promulgated the Regulations for the Protection of Traditional Arts and Crafts, on the basis of which traditional skills are to be preserved, protected, and developed. The Regulation defines that "traditional arts and crafts refer to the kinds of handicrafts including craftsmanship that have an experience of over a hundred years, have been passed down from generation to generation, are manufactured with natural raw materials using a complete technological process, have a distinctive national style and local features, and enjoy great prestige at home and abroad." The Regulations for the Protection of Traditional Arts and Crafts has further included rules for appraising and choosing China Arts and Crafts Masters. During 1979 and 2006, the China Arts and Crafts Masters Appraisal and Choice activities were conducted five times in which 365 masters were chosen. These masters were given a subsidy by enterprises and local governments. Some enterprises with better conditions even set up working rooms for them, with

assistants and students provided so that they could better pass on their skills to their successors. In addition to these nationwide initiatives, Beijing, Shanghai, Jiangsu, Zhejiang, Sichuan, and Jiangxi also chose craftsmen to support towards better working conditions.

In 2003, the UNESCO "Convention on the Safeguarding of Intangible Cultural Heritage" was passed in which traditional arts and crafts skills are included. In 2006, the State Council chose its first list of over 500 items of cultural heritage: these include folk fine art (New Year pictures, weaving and embroidery, sculpture) and traditional handicrafts (ceramics, lacquer ware, printing and dyeing, stationery making). Moreover, there are legends about arts and crafts in "folk literature." It is thus obvious that traditional arts and crafts are a significant intangible cultural

Lisu minority lacquerware bamboo-joint wine pot, 25 x 6 cm, made around 1960, kept in the Shanghai Museum. The vessel is made by placing upside down a three-joint bamboo section taken from the lower part of a bamboo, cut aslant to make the pot mouth, hollowing out the middle joint, putting a handle with a hole on one side for wine to be poured in or out, and making the lowest joint the body of the pot. Black lacquer is applied on the outside and crimson lacquer round the mouth; the handle is fastened with a cord.

heritage in which the relationship between material and non-material can be understood as follows: The materials used in traditional arts and crafts and the articles produced belong apparently to material culture, whereas the artistry, working process, legends about their origin, ingenious design and spiritual symbol are intangible or non-material. Promotion by the state and concern by society have provided a favorable social environment for the protection and development of traditional arts and crafts.

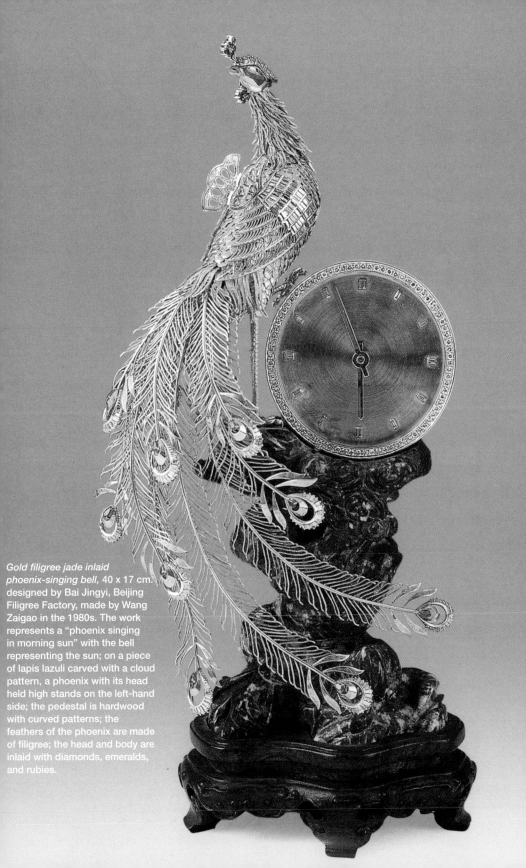

Gold filigree jade inlaid phoenix-singing bell, 40 x 17 cm. designed by Bai Jingyi, Beijing Filigree Factory, made by Wang Zaigao in the 1980s. The work represents a "phoenix singing in morning sun" with the bell representing the sun; on a piece of lapis lazuli carved with a cloud pattern, a phoenix with its head held high stands on the left-hand side; the pedestal is hardwood with curved patterns; the feathers of the phoenix are made of filigree; the head and body are inlaid with diamonds, emeralds, and rubies.

Blue and white porcelain "tower case" (or "Leifeng tower" 31cm in height, Shaanxi, 1990s. The five-layer pot is shaped like a tower with one layer over another, the top layer with a handle. The individual containers are used for condiments such as salt, vinegar, pepper, or pickles. They can be used separately or together, both a space-saving utensil and an ornament.

As the Chinese economy grows, the traditional arts and crafts, with their unique features of drawing on local resources, low energy consumption, low pollution, high added-value, and high earnings, are in conformity with the state strategy of sustainable development. Arts and crafts as a profession still have important industrial value and market value and can assist the development of the rural economy by means of "one village, one type of arts and crafts," or maintain their traditional superiority to become a key local industry or urban cultural symbol, or combine with cultural and creative industries to carry forward the growth of the creative economy. Moreover, traditional arts and crafts, based on manual work and skill, require limited production space and are labor intensive. As an important carrier of Chinese national culture, arts and crafts still play a vital role with multiple values from economy to culture.

Appendix:
Chronological Table of the Chinese Dynasties

The Paleolithic Period	c.1,700,000–10,000 years ago
The Neolithic Period	c. 10,000–4,000 years ago
Xia Dynasty	2070–1600 BC
Shang Dynasty	1600—1046 BC
Western Zhou Dynasty	1046–771 BC
Spring and Autumn Period	770–476 BC
Warring States Period	475–221 BC
Qin Dynasty	221–206 BC
Western Han Dynasty	206 BC–AD 25
Eastern Han Dynasty	25–220
Three Kingdoms	220—280
Western Jin Dynasty	265–317
Eastern Jin Dynasty	317–420
Northern and Southern Dynasties	420–589
Sui Dynasty	581—618
Tang Dynasty	618–907
Five Dynasties	907–960
Northern Song Dynasty	960–1127
Southern Song Dynasty	1127–1276
Yuan Dynasty	1276–1368
Ming Dynasty	1368–1644
Qing Dynasty	1644–1911
Republic of China	1912–1949
People's Republic of China	Founded in 1949